THE ART OF
TOULOUSE-LAUTREC

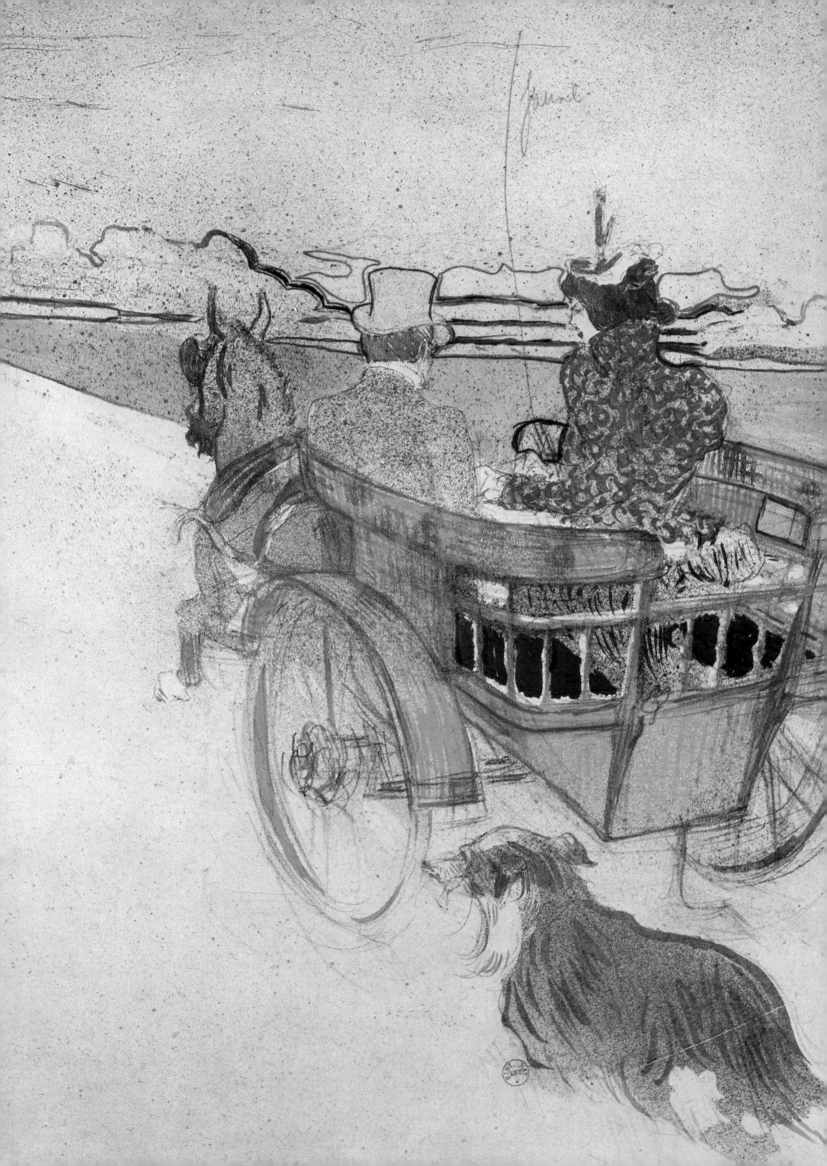

—THE ART OF—
TOULOUSE-LAUTREC
Nathaniel Harris

GALLERY BOOKS
An Imprint of W. H. Smith Publishers Inc.
112 Madison Avenue
New York City 10016

First published in Great Britain in 1981 by
The Hamlyn Publishing Group Limited

This edition published in 1989 by Gallery Books
an imprint of W.H. Smith Publishers Inc.
112 Madison Avenue, New York City 10016

Copyright © 1981 The Hamlyn Publishing Group Limited

ISBN 0-8317-8794-5

Produced by Mandarin Offset
Printed and bound in Hong Kong

Contents

The Greatness of Toulouse-Lautrec

Novels and films have made the life of Henri de Toulouse-Lautrec particularly widely known. Popular fiction must and does distort – it colours and romanticizes, it obscures the fact that great artists tend to be more obsessed with their work than with personal relationships, and it looks for over-simple explanations to account for the nature of a talent or style. In Lautrec's case, it has made too much of his physical misfortunes, important though they surely were. But in most other respects it has hardly needed to colour the facts of his short, wild and self-destructive existence. Here, at least, no great distance separates legend from truth. Toulouse-Lautrec was born into the French aristocracy, but his life was blighted and changed by a bone disease that stunted the growth of his legs, leaving him small and grotesquely ill-proportioned. Excluded from many pursuits of his family and class, both social and strenuous, he made a career in Paris as a professional artist, taking many of his subjects from the bars, music-halls and brothels of Montmartre, where he passed so much of his time. He was himself one of the 'characters' of the district he celebrated, until syphilis and alcoholism broke down his constitution and he died, aged only thirty-six.

Lautrec's talent was extraordinary in its concentration. His works contain no symbols or morals or messages, he had no interest in history or fantasy or emotional

Mademoiselle Eglantine's Troup. 1896. A poster for a dancing troupe that included Lautrec's friend Jane Avril. Private collection.

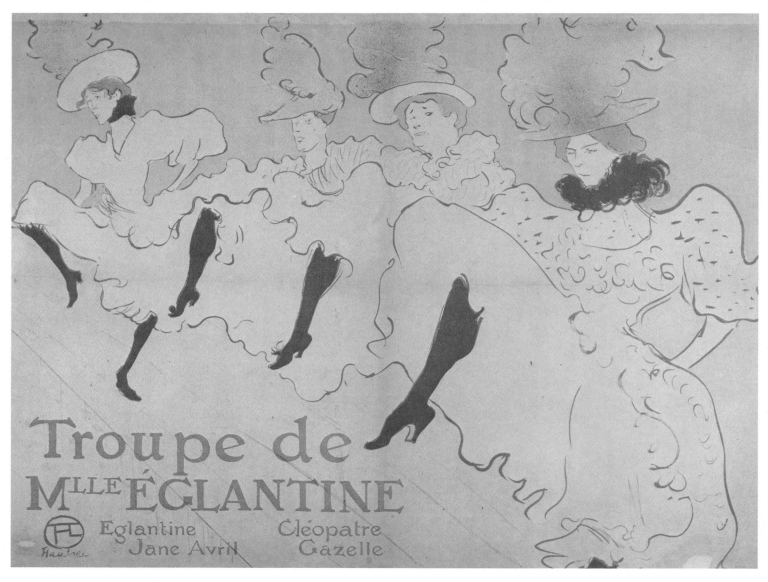

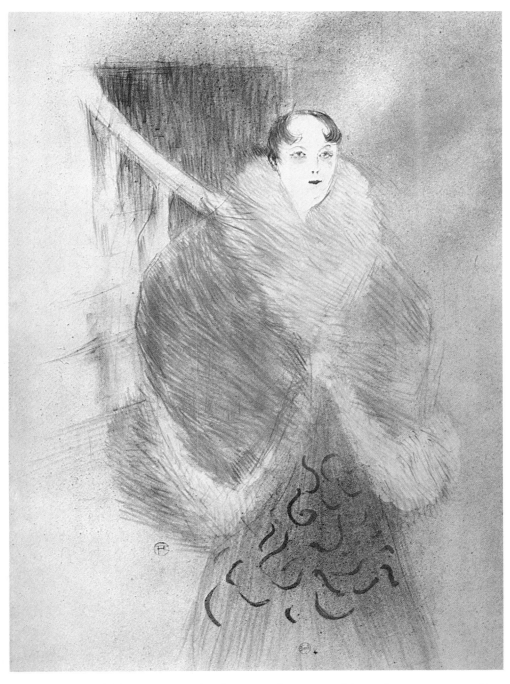

Left: *Elsa the Viennese*. 1897. A lithograph portrait. Cabinet des Estampes, Bibliothéque Nationale, Paris.

Above: *Portrait of Madame Lucy*. 1896. Musée du Louvre, Paris.

expression, and his attempts at landscape – the great subject of contemporary Impressionism – were confined to a few dutiful boyish daubs. Even as a 'painter of modern life' he ignored transport, industry and commerce, except where the commercial transaction involved the sale of entertainment, art or physical pleasure. He is supremely the poet of the night life, which he observes with a clarity that excludes condemnation, sentimentality (or even sentiment), and pity; there is not even a hint of social comment of the sort that his contemporary Emile Zola was making in his novels, describing the effects of alcohol or the connections between poverty, politics and prostitution. At first sight, Lautrec appears to be a 'camera', merely showing us what he sees without judging or becoming emotionally involved with it. But such neutrality is of course an illusion, since the artist always recreates and evaluates the world by his choice of subject, his angle of vision and his choice of technique.

If Lautrec is apparently immune to moral emotion, he is far from passionless; he delights in gamey atmospheres, he feels the glamour of the big music-hall stars, and he responds to the press of people and the excited rhythms of the Moulin Rouge and other night-spots. How else could he make us feel them? He is not neutral; he merely adopts a point of view unusual enough to seem neutral because it excludes so much in the sentimental-moral-social spectrum that others take for granted. It is a restricted point of view, just as his world is a restricted world; what makes it worth entering is the fullness and artistic integrity with which it is

expressed. It is no more reasonable to complain of its restriction than to complain that Oscar Wilde is not Shakespeare, or that Saint-Saëns is not Beethoven. Lautrec is not one of those artists whose work embraces humanity as a whole; but he belongs to the equally honourable company of those who have done a single thing supremely well.

The special, astringent quality of Lautrec's art is appreciated easily enough if we try to apply some of the clichés we have heard about his period. Did he, on the evidence of his work, live *la vie de Bohème*, in Gay Paree, during the 'naughty nineties'? Evidently not. The conventional phrases are obviously absurd in their inadequacy, and Lautrec's men and women are too tough and too stricken by experience to be contained by such shallow, cheerful formulas.

In any art but the most overtly sentimental or moralizing, the point of view – the special quality – cannot be separated from the technique adopted by the artist; in the last analysis, a painting consists of nothing but pigment and canvas, and the way in which these are arranged *is* the point of view, emotion or vision of the artist as the spectator knows it. Lautrec would not be Lautrec without his incisive line and his striving to simplify both line and colour, so that only the quintessence of a scene need be shown. When we survey his development we shall find him studying conventionally before shedding parts of his teaching, then absorbing influences, copying here and stealing there, until he had put together the technical means appropriate to his vision of the world. In his case the process was a remarkably rapid one, virtually completed by the time he had reached his mid-twenties; if the intense particularity of his vision prevented him from going as far as his friend Van Gogh, it also saved him from the dissipation of energies that prevented other, and apparently more gifted, friends such as Emile Bernard and Louis Anquetin from fulfilling their early promise. However, even after this, Lautrec remained capable

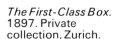

The First-Class Box. 1897. Private collection, Zurich.

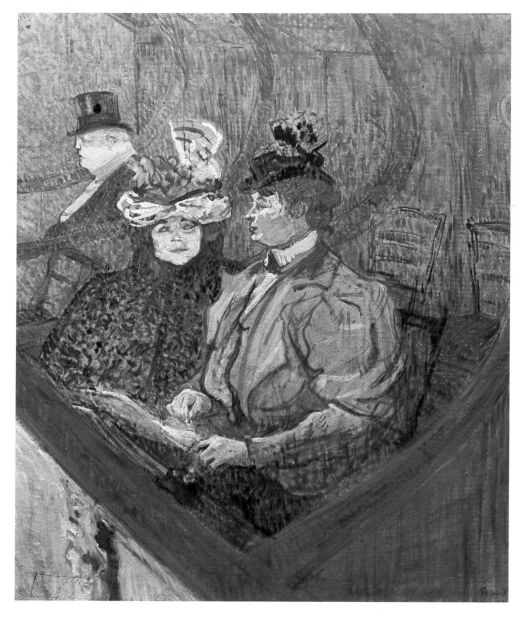

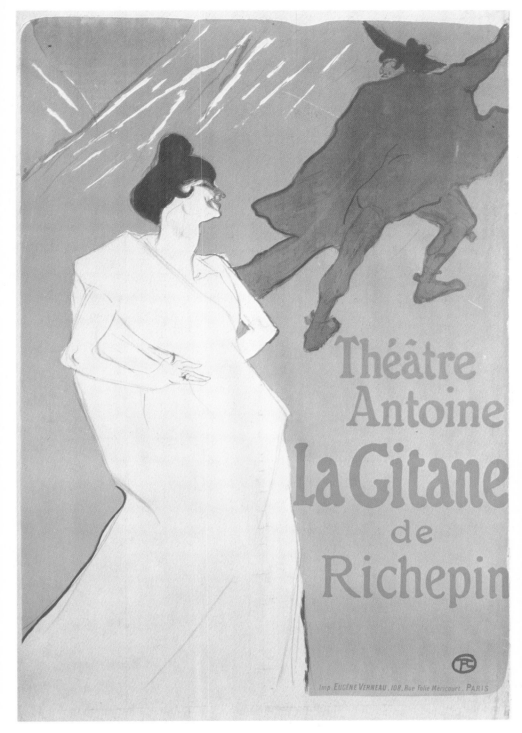

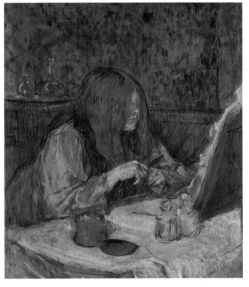

Left: *The Gipsy-Woman of Richepin*. 1900. Poster, featuring the actress Marthe Mellot, wife of Alfred Natanson, for a play at the Theatre Antoine in Paris. Musée Toulouse-Lautrec, Albi.

Above: *Madame Poupoule at her Dressing Table. c.* 1899. Musée Toulouse-Lautrec, Albi.

of recognizing new possibilities when they were offered, and he found in the lithographic printing process a highly effective medium for his mastery of line, colour and simplification. He became the first major figure in a new art – the art of the poster – and in his own day was better known for his achievements in this medium than for his work as a painter. Lautrec's style as a poster artist was immediately acceptable because it worked; a poster obviously had to be eye-catching, and Lautrec's hard outlines and large areas of bright, flat colour quite evidently did the job better than the fussier productions of most earlier artists.

By contrast, there was no functional criterion for most paintings, only a conventional standard upheld by academies; and Lautrec's painting style seemed as outrageous in its way as the styles of Van Gogh, Gauguin and so many other 19th-century artists. Like them, he received no official recognition or encouragement during his lifetime, and had to die before his work began to be properly appreciated. Only two years later, in 1903, one of his paintings was hung in the Musée du Luxembourg, which in those days housed works 'on approval' (so to speak) that might eventually be promoted to the holy of holies, the Musée du Louvre. All the same, his work still had a great deal of opposition to overcome. Finally, in the 1920s, a Lautrec entered the Louvre, while a collection of his work was assembled in a Musée Toulouse-Lautrec in Albi, the town where he was born. Since that time, Lautrec's greatness has never been seriously questioned.

Paris: La Belle Époque

Lautrec's world was an apparently narrow one, which can virtually be summed up as being the world of Paris in the 1880s and '90s – its bohemian society, its night life, its school of art. He had no significant interest in world affairs, or even in the events that were shaking contemporary French society. The Boulanger crisis, the Panama scandal, the notorious Dreyfus case (which unleashed a torrent of anti-semitism, alienated friends and divided families), the rise of working-class social-ism, the anarchist scare – none of these seem to have made the least impression on Lautrec. Like his father, he claimed to be a monarchist, which probably meant no more than that he was contemptuous of bourgeois society and self-exempted from taking part in public life. The only aspect of society to which his work relates is that

The German Babylon. 1894. Poster for a long-since forgotten novel by Victor Joze. Musée Toulouse-Lautrec, Albi.

Right: *Monsieur, Madame and the Dog.* 1893. Lautrec in his most mordant caricaturist's vein. Musée Toulouse-Lautrec, Albi.

Right: *At the Foot of the Scaffold.* 1893. Poster for a series in the newspaper *Le Matin.* Musée Toulouse-Lautrec, Albi.

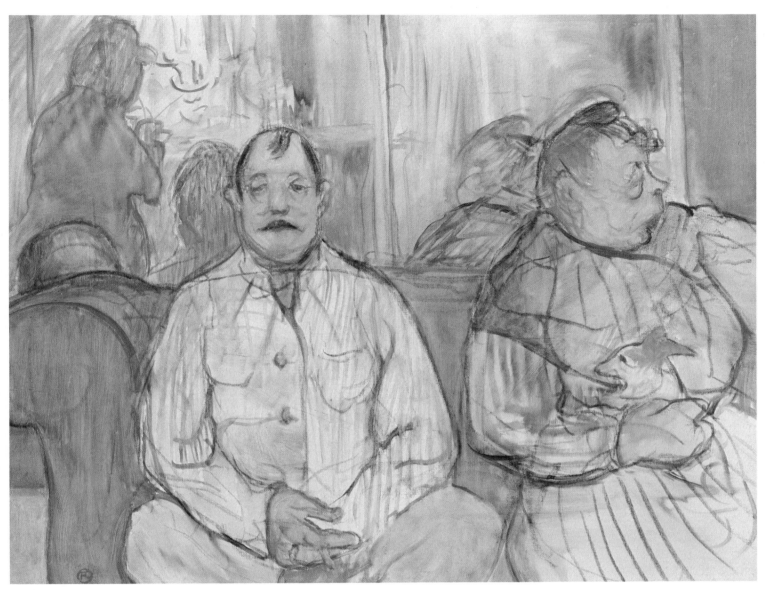

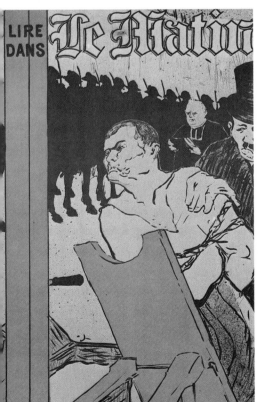

of the Belle Epoque – the pleasure-loving side of late 19th-century life which has seemed so carefree and glamorous since its destruction by the First World War. Though indifferent to its political scandals, Lautrec gives us a rather more candid view of the Belle Epoque than we are used to seeing in film musicals, contemporary photographs and Art Nouveau posters for bicycles and seaside resorts.

It is above all a view of life in the capital. Paris itself was expanding rapidly, and flourishing in an age of industrial revolutions, money-making and technological advance. During Lautrec's lifetime, in 1889, it was the host-city to one of the great international exhibitions in which the nations displayed their 'progress' in both arts and sciences; and the Eiffel Tower – then the tallest building in the world – was constructed as a virtual centrepiece of the exhibition, asserting France's claim to lead the world in the new iron-frame technology. The city had acquired much of its present-day appearance in the 1860s and '70s, with the laying-out of the great boulevards under the supervision of Baron Haussmann, the prefect of Paris. One result of the demolition and rehousing which this involved had been that most parts of Paris lost their mixed character, and rich and poor were segregated into separate districts, which either became smart, or solidly bourgeois, or drably poor, or utterly dreadful, according to the means of their inhabitants. One of the attractions of Montmartre, which Lautrec made the focus of his existence, was that it had escaped this process of categorization, drawing rich and poor, writers and artists, tourists and Parisians, to work or play at widely different levels of culture and reputability. Ironically, in Lautrec's lifetime the crest of Montmartre, so devoted to liberty and pleasure, was being crowned by the slowly rising Church of the Sacré-Coeur. This was a symbol of conservative, Catholic France, intended as a gesture of national repentance after the semi-socialist Commune, bloodily suppressed in 1871; but time has turned its brilliant marble onion-domes into another of the tourist attractions of the district.

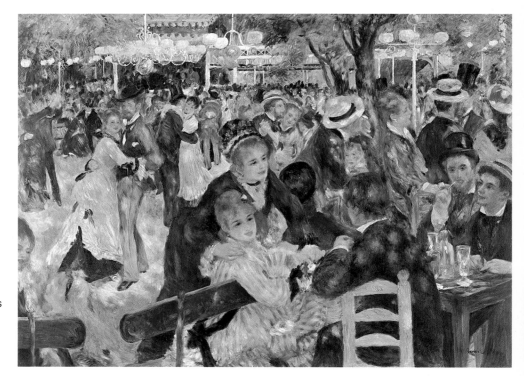

Right: Auguste Renoir. *The Moulin de la Galette*. 1876. One of the chief pleasure-spots of Montmartre as depicted by a major Impressionist painter. The innocent gaiety of this colourful outdoor scene is in marked contrast to Lautrec's view of the same place. Musée du Louvre, Paris.

Above: Edgar Degas. *Miss Lala at the Cirque Fernando*. 1879. A painting of one of Lautrec's favourite haunts by the master he admired most. The unusual viewpoint and composition balance are characteristic of Degas' refined art. National Gallery, London.

In the 20th century Montmartre has lived off its own legend, selling a fake bohemianism to foreign and provincial tourists. Even in Lautrec's day there was a phoney side to the place, designed to persuade thrill-seekers that music-hall dancers and prostitutes were the molls of dangerous gangsters, and that an apache knifing might occur at any moment. But for several decades, from the 1860s to the '90s, Montmartre retained something of a genuine village feeling. It *had* been a village not long before, and even later on, when it was a celebrated place, its distance from the centre of Paris prevented it from becoming too fashionable and expensive for ordinary people; although it had a large artistic colony, for a long time the successful members tended to move out because their wealthy clients were reluctant to come so far to sit for their portraits. Montmartre was (and is) a windswept hill, affectionately known as the *Butte* (the Mound), and its 'trade-mark', the famous windmills, were once more than symbols or relics; the village grew up as a site for milling grain and quarrying gypsum. It was also the nearest village to Paris, which meant the nearest convenient place to drink wine outside the city limits, free of duty. Taverns and cheap dance-halls sprang up, and by mid-century artists were moving in, seizing the opportunity to rent studios that were inexpensive, set in picturesque surroundings, and yet close to the capital. Even after Montmartre formally became part of Paris in 1860, it remained a centre for out-of-town art and entertainment. The Moulin de la Galette, a popular dance-hall, was the earliest of the public places of entertainment to be immortalized by an artist; in 1876 Renoir made it the subject of one of his masterpieces, creating a sun-splashed scene of couples dancing or idling in the open air. Reacting against the dull dignity of official art, painters were attracted to popular entertainments of all kinds. Lautrec's first really ambitious painting, the *Equestrienne at the Cirque Fernando* (1888; Art Institute of Chicago), was inspired by the circus, which was to become one of the commonest subjects of the modern French school of art. Of Lautrec's contemporaries, both Degas and Seurat painted scenes from the Cirque Fernando (later renamed the Medrano), a wooden edifice on the Boulevard de Rochechouart that was one of the great Montmartre institutions.

By contrast, Lautrec had relatively little taste for the cafés which have played so great a part in French cultural life; he preferred more frenetic atmospheres and distrusted solemn theoretical discussions. The café has long been the traditional headquarters of cliques, groups and movements in France; it is the place where ideas are exchanged, ideologies are born, and manifestos are composed. Inevitably, the cafés of Montmartre also assumed this role, displacing some earlier meeting places; for example, most of the Impressionist painters lived outside Paris by the 1880s, but when they visited the capital, they followed the example of Édouard Manet and other avant-garde artists and writers, abandoning the Café Guerbois (although it was not far from Montmartre, in the Batignolles) and congregating at the Nouvelle Athènes, on the corner of the Place Pigalle.

Another feature of the Montmartre scene was the cabaret, a kind of nightclub with performances of poetry or songs, usually with a witty or satirical bite. Originally the writers and artists present had performed more or less impromptu, but soon the performers were professionals (often the proprietors) whose casualness was merely part of their act. The most popular cabarets in Lautrec's time were the Chat Noir (Black Cat) and the Mirliton. The Chat Noir, opened in 1881, was the creation of Rodolphe Salis, an opportunist of genius who promoted not only himself and his cabaret but Montmartre, which he extolled as though it were a great idea or a noble cause. 'What is Montmartre?' he asked, adapting a famous slogan from the French Revolutionary period. 'Nothing. What must it be? Everything!' The proprietor and star of the Mirliton, which opened a few years later, was Aristide Bruant, a *chansonnier* who sang of the pleasures and tragedies of poverty while between times insulting the fashionable audiences who crammed themselves into the cabaret to hear him. The Mirliton was Lautrec's favourite rendezvous until the opening of the Bal du Moulin Rouge in 1889. This was the largest and most popular of the Montmartre music halls, luring away the stars of the previously

Below: Georges Seurat. *The Circus.* 1891. The same subject and the same place as in Lautrec's *Equestrienne at the Cirque Fernando,* treated in Pointillist fashion by the inventor of the technique. Musée du Louvre, Paris.

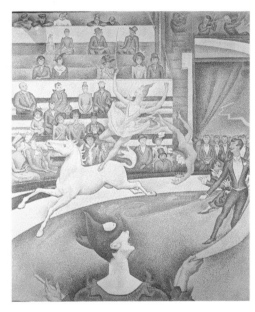

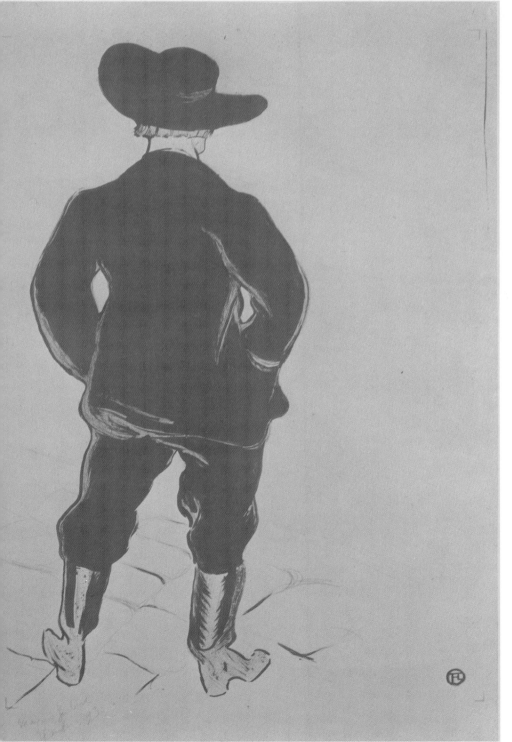

Left: *Aristide Bruant at the Mirliton.* 1894. Lautrec's friend Bruant, a famous *chansonnier,* is shown in characteristic garb and pose in this poster. Musée Toulouse-Lautrec, Albi.

13

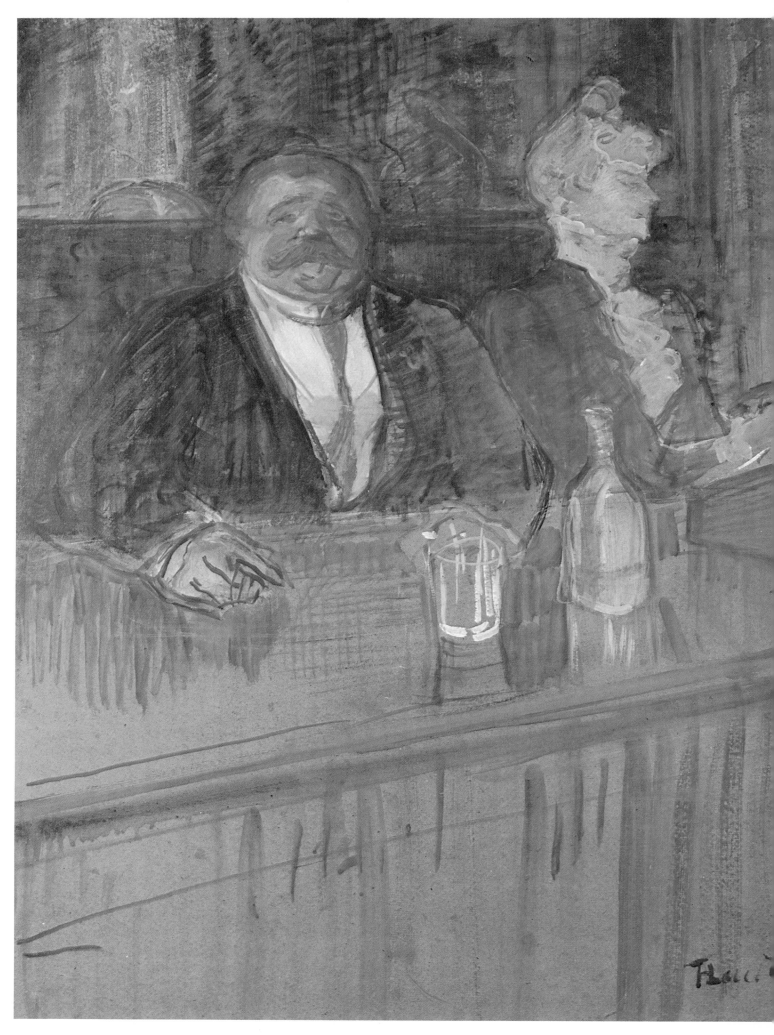

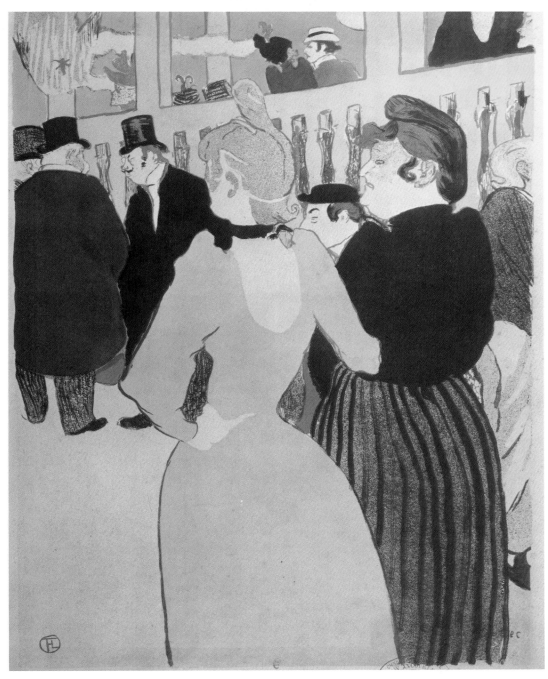

supreme Elysée-Montmartre and successfully maintaining itself against rivals such as the Divan Japonais and the Casino de Paris. The greatest stars of the Moulin Rouge were its dancers, and it is identified above all with the can-can, which has passed into the history or myth of Montmartre. Actually the dance had been devised some thirty years before the Moulin Rouge came into existence, by which time it was being performed in an amended version called the quadrille. But it was there that the dance and the dancers caught the wider public's imagination, and of course found their most gifted historian in Toulouse-Lautrec. The girls, with their provocative low-life nicknames (La Goulue, 'The Glutton'; Grille d'Egout, 'Sewer-Grid'; La Môme Fromage, 'The Cheese Kid'), really do seem to have sent audiences into frenzies with their displays of frothing frilly underwear, high kicks, shrill cries and acrobatic final splits. The excitement generated overflowed into a mainly commercialized erotic activity which had become increasingly typical of Montmartre, where there was flesh for sale to suit all tastes and inclinations.

Lautrec not only patronized but also sketched and painted in brothels, but he preferred the establishments in the heart of Paris for this purpose; some of these were quite palatial affairs, decorated in all sorts of pseudo-historical styles to cater for their customers' fantasies. Lautrec was by no means alone in doing much of his work in brothels; the master he most admired, the aloof Degas, was one of several artists who found the habitually naked or half-clothed 'girls' more natural and casual in their gestures and movements than professional models.

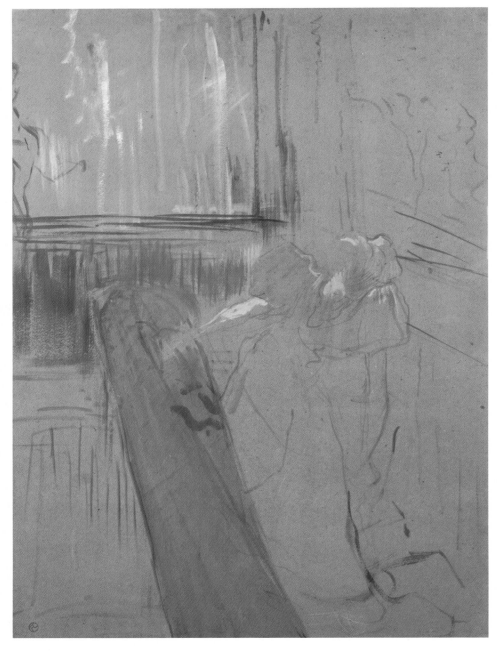

No doubt there was more to it than that. Vice had a special allure during the Victorian age, with its rigid moral code which demanded absolute conformity or at least a rigorously maintained hypocrisy. One reaction among French writers and artists was what can only be called a 'cult of the prostitute', which can be traced from Dumas' *The Lady of the Camellias* and the poems of Baudelaire in the 1840s and '50s to Zola's *Nana*, the Goncourts' *Fille Elisa*, and other novels of the '80s. The manifold attractions of the subject are obvious; it could be moralized, or sentimentalized, or treated with a ruthless realism, while shocking and alluring a prurient public that slummed (or only dreamed of slumming) in the forbidden places. It was all part of a larger emotion known as *nostalgie de la boue*, which might be loosely translated as 'sweet remembrance of the sewer' – an emotion voiced only by disreputable bohemians but covertly acted upon by a sufficient number of respectable persons to create armies of prostitutes in Paris, London and other big cities. Needless to say, the main difference between France and the rest of Europe lay not in the realities of the situation but in its expression; somehow or other, French writers and artists were much more successful in defying or evading censorship than their peers in other countries, and it is primarily for that reason that 19th-century French art is generally more mature than its contemporary equivalents even where it is not the product of a superior genius.

This was, of course, one of the great ages of French painting. It was also an age in which the greatness was almost exclusively confined to painters of whom the authorities and most of the buying public disapproved. The 19th century gave birth to the notion of an avant-garde – a body of artists whose works were in ad-

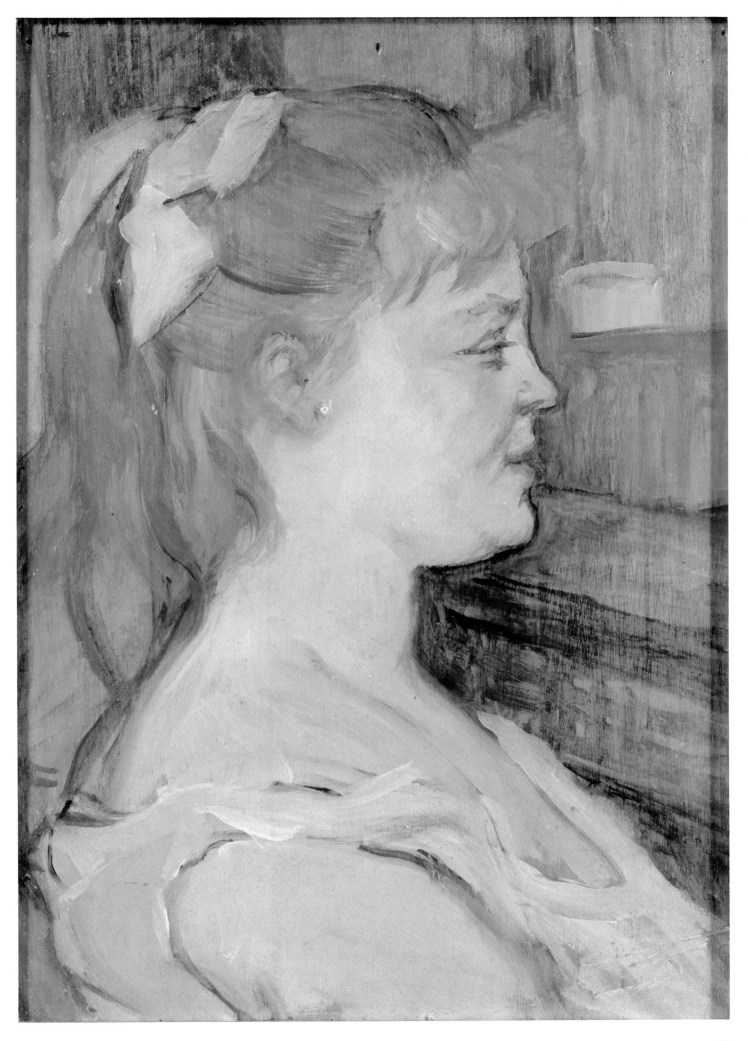

Right: *Woman at the 'Tub'*. 1896. A rather cheeky treatment of a subject dear to Lautrec's master, Degas. This lithograph comes from the series *Elles* ('Women'). Cabinet des Estampes, Bibliothèque Nationale, Paris.

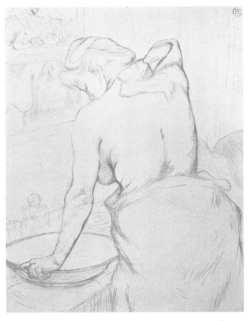

Above: *Woman Washing her Back*. 1896. Lithograph from the series *Elles*. Cabinet des Estampes, Bibliothèque Nationale, Paris.

vance of current taste instead of merely seeking to satisfy it, as they had always done in previous centuries. The existence of an avant-garde implies the countervailing existence of an establishment and an artistic orthodoxy; and no nation had a more powerful establishment and orthodoxy than 19th-century France. Any painter who hoped for success went about his career in the spirit of a civil servant. He enrolled at the Ecole des Beaux-Arts, where he studied under sound teachers, drew and painted in the approved style, and competed for the prizes offered by the Ecole; to win one was to take a long step forward on the road to eminence. Having graduated, he regularly submitted his work to the Salon, the official show held every year and thronged by the solid middle-class public; only there could he hope to find buyers and – the supreme accolade – see one of his works acquired by the State. With age and success would come official commissions and, if such were his *métier*, lucrative orders for portraits; and his career would be crowned by admittance to the Academy of Fine Arts and nomination to the ranks of the Legion of Honour. Since the Academy elected its own members and effectively controlled both the Ecole des Beaux-Arts and the Salon, the system was largely self-perpetuating. And so, naturally enough, we still call the orthodox official art of the 19th century 'academic'.

Academic painters were often superbly competent in manipulating their prescribed techniques, producing highly finished pictures with carefully smoothed-down (that is, invisible) brushwork. They are still to be seen in most national and municipal galleries, and we often marvel at their near-photographic accuracy in certain respects while simultaneously becoming conscious of their staginess and sentimentality. Academic artists saw the world in the light of certain conventions, both technical and moral, and the moral conventions were the more destructive of the two. They were consistently sentimental, which is to say insincere. They did not simply ignore the ugly sides of (for example) poverty, war and sex; they prettied them up. Poverty is made picturesque; war becomes a matter of glorious charges and pathetic deaths – but not of agonies or mutilations; sex is often a powerful presence, but slyly 'innocent', hairless and odourless. History painting was enormously popular because it was even further removed from disturbing realities while giving painters scope for work on the grand scale. Here, the more rigorous-minded academic painter could earn his salt by laborious research into the costumes of Charlemagne's time or the order of precedence at Napoleon's court, while others moved towards more 'imaginative' subjects where history, myth and fantasy were virtually indistinguishable. As more and more subjects were worked over to the point of exhaustion, history painters came up with increasingly obscure and bizarre episodes, sometimes culminating in absurdities such as the *Return from a Bear Hunt in the Stone Age*, by Lautrec's teacher Fernand Cormon – an absurdity that was nonetheless purchased by the State at the Salon of 1884.

Given his aristocratic background, Lautrec might have been expected to make a thoroughly conventional career; indeed, his family counted on it, and he was in fact slower to rebel than many of his contemporaries. But rebel he did, moving into Montmartre and leaving Cormon with an aristocratic minimum of fuss. He might never have done so if the way had not been prepared (for him and for others) by the Impressionist painters in the 1870s. Although there had earlier been isolated acts of defiance towards academicism (notably by Gustave Courbet), the Impressionists were the first substantial group to go their own way, and the first to do the unthinkable – to by-pass the Salon and mount a large independent exhibition. The first show of 1874, and the seven that followed in the period down to 1886, were very mixed affairs. 'Impressionist' was an unofficial and derisory label, applied specifically to the paintings of Claude Monet by an unfriendly critic; and it was completely appropriate only to a few exhibitors – Monet himself, Auguste Renoir, Camille Pissarro and Alfred Sisley. Their works looked like 'mere impressions' to the conventionally-minded because they took their canvases into the open air and tried to capture the fleeting aspects of the natural world. Instead of the fused and smoothed brushwork of orthodox art, laboriously accomplished in a studio, they used small strokes of bright primary colours, painting the complicated variety and shimmer of tints that is actually seen in sunlight and shadow, rather than the conventional version of reality that made nudes pink in all lights, and roses red, and shadows black. Seen from a few inches away, Impressionist paintings are blurred, multi-coloured masses of brush-strokes (contemporary critics chose to look at them in that way, and could therefore dismiss them as daubs); but when they are viewed from a distance, the colours are mixed by the spectator's eye while

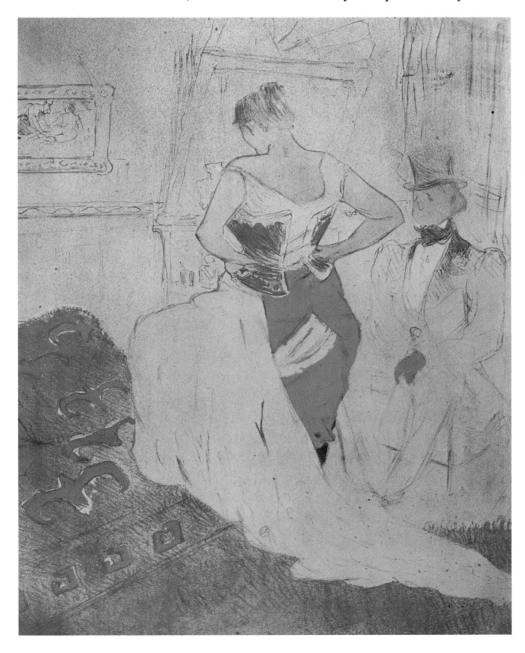

Woman Putting on her Corset. 1896. Lithograph from the series *Elles.* Cabinet des Estampes, Bibliothèque Nationale, Paris.

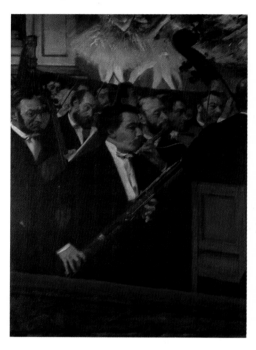

Right: *Woman Looking at Herself in a Mirror.*
1896. Lithograph from the series *Elles*.
Cabinet des Estampes, Bibliothèque
Nationale, Paris.

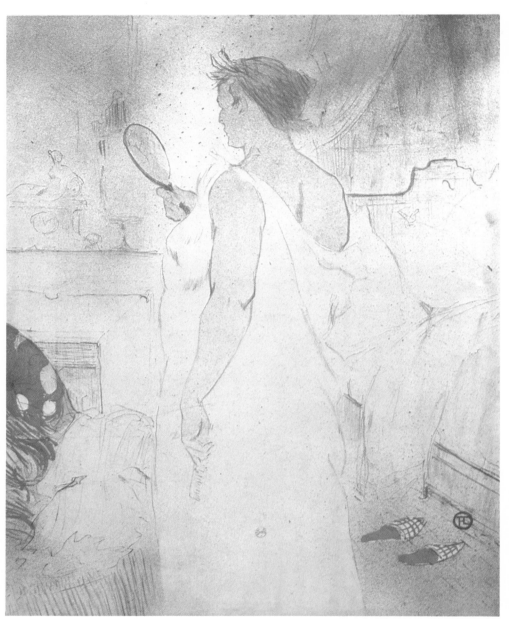

Above: Edgar Degas. *The Musicians of the
Orchestra.* 1868. Lautrec's friend Désiré
Dihau can be seen in the centre playing the
bassoon. Musée du Louvre, Paris.

retaining their primary freshness and the vibracy created by their juxtaposition. It
is hardly necessary to dwell on the bright, gay, spontaneous atmospheric qualities
possessed by these works, which are now almost universally popular.

In the 1880s the Impressionists were still controversial figures, although they
had begun to disperse, and to diverge in their artistic aims. Lautrec had no signifi-
cant contact with these 'outdoor' Impressionists, whereas he was overwhelmingly
influenced by one of the moving spirits of the group who nonetheless shared only
their rebellion and their interest in 'modern life'. Edgar Degas was a difficult,
haughty and disdainful man who grew more cantankerous and isolated as he grew
older; he detested the word 'Impressionist' and, insofar as he submitted to any
such formulation, preferred to call himself a realist. On occasion he expressed his
approval of Lautrec's art, but even the possession of such a gifted disciple made no
appeal to his human sympathies, and the two scarcely ever met. Yet Lautrec's
enormous debt to Degas is impossible to doubt. Degas' 'modern' tastes appeared
in his choice of subjects – horse racing, the theatre, the ballet, the circus,
laundresses at work or lounging about, naked women prosaically scrubbing or
drying themselves, shops, cafés, bars, brothels; and these are obviously very close
to Lautrec's concerns. (There *were* differences, of course. Lautrec was much more
interested in popular entertainments than in the theatre or ballet, and he preferred
to paint women partly clothed rather than naked; in general, the upper-class
Lautrec had a more marked taste for zestful vulgarity and sordid low-life – and
more egalitarian manners – than the middle-class 'aristocrat' Degas.) Degas'
superb draughtsmanship also had a special appeal to Lautrec; even the most freely
executed of his paintings and pastels is 'drawn', with visible outlines defining
figures and objects in a manner alien to the Impressionism of Monet. In this

instance it would be wrong to think in terms of Degas influencing Lautrec; it was rather a case of like speaking to like, for Lautrec's gift for drawing – and his passionate preoccupation with it – became apparent quite early in his life.

A distinctive technique of Degas' that he did very effectively take over was the 'cut-off'; instead of placing all the figures and objects wholly within the picture frame, Degas frequently painted some of them so that they were truncated by the edge of the composition. Dancers' heads might be 'missing' at the top, or a gentleman's elbow or the hindquarters of a horse cut off at the side. The effect was like that of a photograph – an action snap-shot that, once taken, cannot be corrected if the subject turns out to have been mis-framed. In the works of Degas and Lautrec, this apparent arbitrariness is of course the result of careful deliberation, yielding strikingly original compositional effects and imparting a special kind of energy to the entire picture area. It may in fact have been suggested by photography, which has been identified as a likely source for several painterly devices used by the Impressionists. Significantly, Nadar, one of the leading photographers of his time, was friendly with them, and the epoch-making exhibition of 1874 was held in his premises on the Boulevard des Capuchins. From about this time, many painters regularly used photographs to help them in their work, and the very existence of the exact new art probably encouraged Lautrec and others like him to abandon 'photographic' painting.

Another source for the cut-off technique was the Japanese colour print, which began to reach Europe after the forcible opening of Japan to the West in the 1850s. These prints, executed by a woodblock technique, were a cheap and popular form of art in Japan, and were therefore held in relatively low esteem; it is said that many examples reached Europe in the holds of merchant ships, as wrappings for other

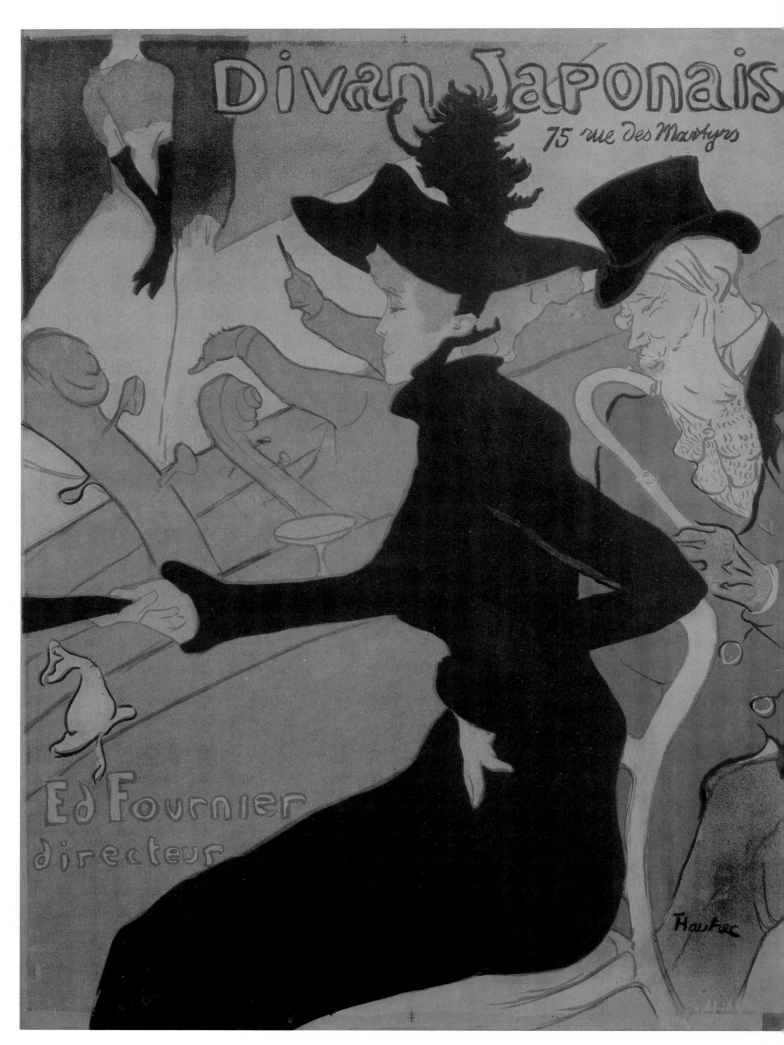

Japanese goods. But their impact on artists was tremendous, reaching its height in the last two decades of the 19th century, when there was a powerful movement towards decorative art styles. Apart from its cut-offs, the Japanese print was characterized by an exceptionally bold linear style and large areas of bright, flat (that is, unbroken and unshaded) colour. These were, above all, the characteristics of Lautrec's posters, which almost overnight made the fussier styles of his rivals obsolete. However, *Japonaiserie* had an even wider influence, becoming an all-pervasive cult in the 1880s that manifested itself in all sorts of ways. Lautrec, who admittedly enjoyed any kind of dressing up, on one occasion had himself photographed in authentic-looking Japanese costume, his kimono and fan and the Oriental doll on his knee combining somewhat uneasily with his full beard and pince-nez. And Montmartre had its own Divan Japonais, 'Oriental' in decoration throughout, which was Lautrec's favourite night-spot for a time. while he was obsessed by the singer Jane Avril.

Impressionism, photography, Japanese art – these and other influences combined to liberate the most talented individuals from the bondage of academicism. In the 1880s and 1890s new styles proliferated and Paris became alive with geniuses and movements of greater or lesser authenticity and staying-power. The Impressionists had dispersed, Cézanne remained in the south, forging his own style of monumental modernism, and Gauguin was only intermittently in the capital, drawn to distant places by the dreams to which he gave enchanting form in neoprimitive decorative paintings; but there were plenty of new, mostly younger, faces.

Georges Seurat painted *Sunday Afternoon on the Grande Jatte* and other masterpieces in a technique which he called Pointillism, taking Impressionist practice to its limit by building up the picture entirely with tiny dots of pure colour. He made large claims for the technique as the only scientific way of painting, and for a time even converted the veteran Impressionist, Pissarro; but Seurat died young and, confined to the efforts of his followers, Pointillism never again looked so convincing. Pierre Bonnard, Edouard Vuillard and Maurice Denis developed individual decorative styles, in Denis' case touched with mystical meanings; Emile Bernard fertilized others without discovering within himself adequate resources of conviction and talent; Odilon Redon, though belonging to an older generation, looked forward to the mood of the '90s in his fantastic art of symbols, grotesques and nightmares. Finally, there was the Dutchman Vincent van Gogh, painfully working his way through Impressionism and Pointillism in Paris until he left for the south. There he achieved his own unique mode of expression, perhaps more intense than any mind could endure, before his descent into madness and suicide.

Toulouse-Lautrec knew most of these men, and some of them were his friends; Van Gogh was numbered among them, despite the utter dissimilarity between the earnest Dutch pastor's son and the capricious, cynical French aristocrat.

Paris and art in the 1880s and '90s – a small place and a brief time; but can we really say on reflection that the world of Toulouse-Lautrec was a narrow one?

Far left: *Le Divan Japonais*. 1892. Lautrec's poster for this establishment shows the dancer Jane Avril and the critic Edouard Dujardin as the audience. The singer, headless but recognizable by her long black gloves, is Yvette Guilbert. Musée Toulouse-Lautrec, Albi.

Below: Vincent van Gogh. *The Moulin de la Galette. c*. 1886. Glasgow Art Gallery and Museum, Scotland.

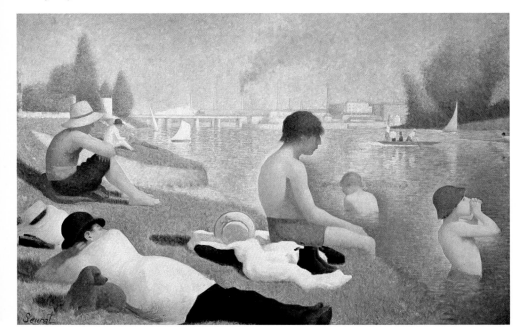

Left: Georges Seurat. *Bathers, Asnières*. 1883–84. Redolent of Parisian pleasures in the late 19th-century 'Belle Epoque'. National Gallery, London.

Youth and Apprenticeships

Henri Marie Raymond de Toulouse-Lautrec Montfa was born on 24 November 1864 at the Hôtel du Bosc, the town house of his family in Albi. His father Count Alphonse and his mother Countess Adèle (née Tapié de Céleyran) were first cousins, a fact that has sometimes been cited as the cause of Lautrec's physical infirmity. Intermarriage was certainly common in the family, which was an ancient one claiming descent from the medieval counts of Toulouse who had defied the kings of France and protected the Cathar heretics of Provence against the huge crusading armies that descended upon them from the north. In more recent times the family had been undistinguished, but it remained comfortably wealthy. Apart from stays at the Albi town house and visits to Paris, the Toulouse-Lautrecs spent their time at the family headquarters, the Château de Bosc in the countryside outside Albi, or on the Céleyran estates in Languedoc. They led the lives of minor provincial nobility, gracious, enclosed and rather aimless; the main illusion of purposeful activity was provided by the several varieties of hunting and shooting, passionately and regularly indulged in. However, there was a persistent artistic streak in the family, both the male and female members enjoying drawing and modelling to an extent unusual in people of their class. In this favourable atmosphere, Lautrec's leanings showed themselves in storybook fashion, and he

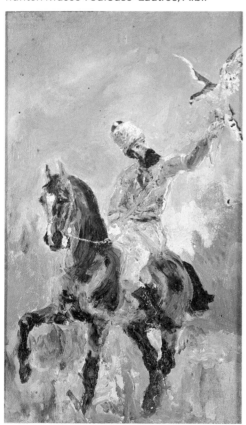

Below: *The Falconer*. 1881. This early painting by Lautrec is a portrait of his father, Count Alphonse, who was a passionate hunter. Musée Toulouse-Lautrec, Albi.

Right: *The Countess Adèle de Toulouse-Lautrec*. 1883. A portrait of Lautrec's long-suffering mother, whose devotion helped to make his brief existence tolerable. Musée Toulouse-Lautrec, Albi.

filled the margins of his school exercises and books with little sketches, as though that was, from the beginning, the natural way for him to approach the world.

Countess Adèle submerged herself into the role of a loving mother, which she maintained all her life; and as a result – unjust, though common enough – she makes a fainter posthumous impression than her wilful and eccentric husband. Count Alphonse was mad about hunting – especially falconry – but he also had two other passions. He loved dressing up; he appears as a Circassian in his son's painting of 1881, and in photographs as a medieval Crusader and a Scottish Highlander. His choice of costume gives us a clue to his difficult, unstable personality, unable to come to terms with the modern world and so living in fantasy among more primitive peoples for whom hunting, war and honour were the central preoccupations of life. The count's other passion – women – had the compulsive and almost undiscriminating quality we should expect to find in a man who was full of vitality and had nothing of importance to do with himself. Moving restlessly from place to place, with nothing to hope or fear from other people, he became steadily more eccentric, marching about Albi with his shirt-tails hanging out, 'forgetting' his wife was with him and leaving her behind on station platforms, and, in Paris, wearing a Caucasian helmet or full Kirghiz costume in the Bois de Boulogne and washing his own shirts in the gutters of the Rue Royale in outrage at the incompetence of laundresses.

The count's antics and infidelities rapidly destroyed Countess Adèle's love for him. One more child was born to them, in 1867; after its death in the following year, relations between them seem to have come to an end, although the conventions were observed. If only for that reason, the Countess and Henri followed Alphonse to Paris when he decided to settle there in 1872. They took apartments in the Hôtel Pérey, off the Faubourg Saint-Honoré; the area, close to the Champs-Elysées, the Rue Royale and the Tuileries, had an upper-class ethos utterly unlike that of Lautrec's later haunts in Montmartre. Lautrec was sent to the Lycée Fontanes, later known as the Lycée Condorcet (it became the most famous school in France, sending out into the world a galaxy of writers, political figures and other notables). He seems to have been a conscientious student, and, though his health was already giving some cause for alarm, won his share of prizes. He made two particularly good friends. One was his cousin, Louis Pascal, who played a relatively small part in Lautrec's adult life but who, in 1893, became the subject of an elegant, Degaslike portrait in oils. The other was Maurice Joyant, who lost touch with Lautrec for years but was to re-emerge as perhaps the closest friend of his later life.

Another companion in Paris was Count Alphonse, who began to take an interest in his son once he was old enough to mount a horse. He went with Henri to the boy's riding lessons, and took him to race meetings and the Bois de Boulogne, where he could see an endless procession of the fashionable and wealthy pass by on horse-

back or in their carriages. For some years, Lautrec – who was later to show only a limited interest in anything but the human animal – shared his father's delight in horses, which are the subject of some of his earliest surviving works. Count Alphonse took him with him when he visited René Princeteau, a successful painter of horses and hounds with a conventional but far from despicable talent. Princeteau, born a deaf-mute, had succeeded in leading a normal life by doggedly learning to speak and lip-read, and by acquiring a range of social and artistic skills. Later on, their shared experience of physical affliction created an important bond between Princeteau and Lautrec, but at this time such a contact simply had the effect of further stimulating Lautrec's enthusiasm for drawing. Count Alphonse, who had studied under Princeteau and kept his own studio in the Hôtel Pérey, evidently saw nothing amiss in his son's artistic leanings, least of all when horses and hounds figured so largely in them.

But despite his outdoor interests and his eagerness to begin hunting, Lautrec was not robust; he was also small for his age – his schoolfellows called him 'little man' – and the awaited phase of rapid growth never occurred. He was often ill enough to be absent from school for long periods, and eventually, in the winter of 1874–75, his health was so bad that his mother took him away from the Lycée for a 'cure' at a spa. In retrospect it is clear that Lautrec was not crippled by the accidents of a few years later; the accidents were by-products of a constitutional weakness that had already manifested itself.

Instead of taking Henri back to the Lycée and Paris, the Countess settled with him in the south-west, where they lived on one or other of the family properties. From this time onwards she devoted herself exclusively to her crippled son, and for some years was the central figure in his life. Count Alphonse, disappointed in his hopes of a filial hunting companion, became increasingly distant and self-absorbed – absent for most of the time, though not formally separated from the Countess, and given to sudden whirlwind arrivals, exhibitions of oddity and abrupt departures. Lautrec was now taught by private tutors, but he was far from lonely or isolated in the family homes, where he had an army of younger cousins to command. He was already capricious, mischievous, mocking and self-mocking, and boisterously high-spirited and energetic – all qualities for which he was con-

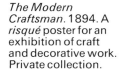

The Modern Craftsman. 1894. A *risqué* poster for an exhibition of craft and decorative work. Private collection.

Woman at the Entrance to a Box. 1894. Musée Toulouse-Lautrec, Albi.

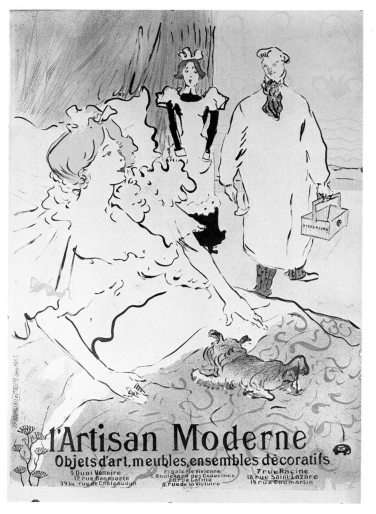

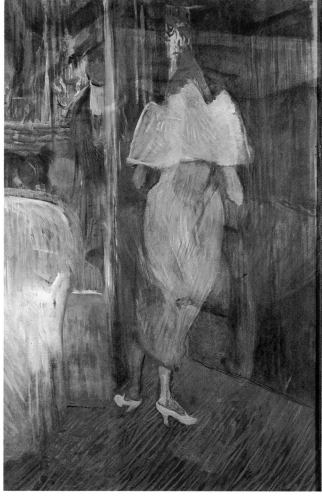

Woman at her Toilet.
1896. Musée du
Louvre, Paris.

spicuous in adult life. But his physical condition remained worrying, and he seems to have used a stick to help him walk; he was using it one day in May 1878 to hoist himself from a low chair, when he slipped and fell, fracturing his left thigh-bone. The accident was not serious in itself, but it revealed the weakness of Lautrec's limbs, which appeared all the more alarming as the bone mended with agonizing slowness. More 'cures' and a winter at Nice followed, but in August 1879 there was a second accident, this time at the Barèges spa: while out for a walk, Lautrec slipped into a shallow ditch and broke his right thigh. After this it soon became clear that he would be a badly disproportioned adult; in particular, his legs grew hardly at all and his head became too large for his torso. He was very short but not, as is commonly supposed, 'dwarfish'; it has been pointed out that, at about five feet tall, he would have been eligible for military service. His lack of height is accentuated in contemporary photographs because so many of his friends were very tall; Lautrec enjoyed the ludicrousness of such contrasts, but also liked the company of his bigger friends on the streets for the most practical of reasons – to make sure that he was not mocked or bullied by louts, for whom he would otherwise have been an obvious butt. His walk, even with a stick, was an ungainly waddle; he lisped and tended to spray saliva when he talked; and, as though nature had not inflicted enough misfortunes upon him, he was ugly. He had a big nose, full, fleshy lips, and a receding chin that he hid under a beard; and he was short-sighted and wore pince-nez. It was the sort of ugliness that can actually seem pleasing or irresistible if it is not

27

accompanied by other physical disadvantages such as Lautrec's; and even he could make his friends forget his appearance when he was in the mood to be charming and gay.

Like other disadvantaged people he cultivated a personality that enabled him to cope with the world. He developed a vein of self-mockery (which anticipates and, by anticipating, spikes the insults of others), and he used his weakness to exert a kind of licensed spoiled-child dominance over friends who would not have tolerated orders, pranks and caprices from someone less vulnerable. His life-style and choice of career also had a kind of shrewdness, despite its self-destructive element. After all, the society of his own class had nothing to offer him; as an embarrassing, unmarriageable 'freak' he would have been even worse off than his aimless, unsatisfied father, who could at least marry, hunt and seduce in order to distract himself. A more pious boy might have repudiated the worldly scheme of things in which he made so poor a showing, by discovering a vocation for the priesthood or monastic life. Instead, Lautrec made art his vocation and Montmartre and similar places his milieu – a vocation in which he could attain an eminence denied the freakish society man, and a milieu in which oddity was almost the norm and sex was so all-pervasive that desire, commerce and love became impossible to distinguish from one another in a way that can only have comforted the ill-favoured man. It was a meaningful, if dangerous, life to choose.

None of this could of course have been predicted during and immediately after Lautrec's accidents. However, immobility did set him painting and drawing more energetically than ever. He was still most fond of animals as subjects, but at Nice he added carriages and ships to his repertoire. Le Bosc, between accidents, provided variations on the theme of glamorous horsemanship when army manoeuvres were

Countess Adèle de Toulouse-Lautrec. 1887. A portrait of Lautrec's mother in the drawing room of her house at Malromé in south-west France, where the painter spent most of his summers. He has signed the picture 'Tréclau', a Lautrec-anagram that he employed for a time when his father objected to the use of the family name. Musée Toulouse-Lautrec, Albi.

staged nearby; Lautrec painted a free, vigorous *Artilleryman Saddling his Horse* and a number of works in a similar vein. The stirrings of ambition became apparent in his ardent response to friends' requests for illustrations, albeit only for a school-boy magazine and a novel that remained unpublished. As his confidence grew, he occasionally attempted landscapes (with mediocre success) and began to paint portraits of himself and his relations. Understandably enough, in view of his age, Lautrec's style was uncertain, at one moment muddily over-ambitious, as in the *Self-Portrait* of 1880, and at another quite charming in a rather child-like fashion, as in the aforementioned portrait of his father, dressed as a Circassian, on horse-back with his falcon (both paintings are in the Musée Toulouse-Lautrec at Albi). At this time he was still painting animals more convincingly than human beings.

In 1881 Lautrec and his mother went to Paris so that he could sit his first *bac-calauréat* examination (university candidates had to pass both parts). He failed at his first try, in July, returned to the south, and succeeded at a second attempt in November 1881 at Toulouse. He then refused to go on with his studies and insisted on becoming a painter. He had probably been much encouraged by contact with Princeteau in Paris; he had had the run of his father's studio, had copied a number of Princeteau's sketches so skilfully that the older painter was not always certain which was the original, and had enjoyed mixing with the smart and distinguished artistic set that comprised Princeteau's circle of friends. Though he still wished to emulate successful and prolific painters of horses, he showed something of his future tastes in greatly admiring Jean-Louis Forain, at this time one of the least-known of Princeteau's set. Forain was a painter, associated with the Impression-ists, who made ends meet by doing spare, sharp little sketches of Parisian life for the newspapers; significantly, he was a friend of Degas.

Lautrec's parents seem to have let him have his way without offering much resistance; presumably they realized that there were only too few careers in which he could hope for success or recognition. Besides, painting was a perfectly respectable occupation if studied and pursued in the approved manner. And so it was arranged that Lautrec should enrol at the Ecole des Beaux-Arts after first preparing himself by working in the studio of an established painter. This proved to be Léon Bonnat, the most sought-after portraitist in France and a sworn enemy of Impressionism and all the other creative tendencies in contemporary art. By this time, Montmartre was such an artistic centre that even Bonnat had his studio on the edge of the area, in the Impasse Hélène just below the cemetery of Montmartre. But Lautrec, who appeared at Bonnat's in March 1882, was far from a wild student; he continued to live with his mother at the Hôtel Pérey, he dutifully admired the conventional 'masterpieces' of the year at the Salon, and he did his best to curb his own inclinations – towards incisiveness of line and bright colours – and draw and paint as Bonnat directed. According to the respected academician, Lautrec's drawing was 'atrocious' – a classic misjudgement that Bonnat seems never to have modified. He eventually became Chairman of France's Museums Council, where for twenty-odd years (1899–1922) he tried to prevent the state from acquiring good modern paintings, reserving his greatest venom for the works of Vincent van Gogh and his own sometime pupil Henri de Toulouse-Lautrec!

Fortunately for Lautrec, his stay with Bonnat was brief; the studio was closed at the end of the summer term, and Bonnat's pupils had to look for a new master. They – including Lautrec – found him in the person of Fernand Cormon, an enormously successful history painter with a studio only a few blocks away from Bonnat's. It was a popular place, since Cormon – by contrast with Bonnat – had remained pleasant and unaffected in spite of his successes. His most famous picture to date was *Cain*, which had been the sensation of the 1880 Salon; now, having ransacked history and myth for subjects, he had arrived back in prehistoric times, and would soon have another triumph with his *Return from a Bear Hunt in the Stone Age*. Clearly the set tasks at Cormon's would be notably different from those at Bonnat's, or from anything Lautrec had done before. During the summer of 1882 he had painted a number of peasant studies at Céleyran which show a considerable advance in composition and solidity of modelling that may derive from

Bonnat's teaching. However, a painting such as *Young Routy at Céleyran* has a lightness of colouring and rustic sentimentality that probably reflects the influence of artists like Jules Bastien-Lepage, who were becoming fashionable by practising a kind of vulgarized Impressionism. Lautrec was still adaptable enough to start working on allegories and fake historical subjects under Cormon's guidance; like many young painters he was having difficulty in finding his own style, and (to begin with, at least) his background inclined him to believe that there was a 'correct' way of doing things which could be learned from qualified persons. By 1884 he had come to different conclusions, embodied in an amusing parody he painted of Puvis de Chavannes' *Grove Sacred to the Muses and Arts*, another Salon favourite; Lautrec makes his comment by introducing a queue of contemporary painters into the picture, with his own diminutive bowler-hatted figure at the front. Evidently the embryo 'painter of modern life' had begun to find the never-never-land of high-minded allegory more than a little ridiculous.

The new friends he made at Cormon's probably helped to disillusion him with academic teaching. They included Louis Anquetin, who was easily the most promising pupil in the studio, and Émile Bernard, in whom the spirit of revolution and ideological passion burned particularly strongly. Together, Anquetin and Bernard experimented with Seurat's Pointillism and other modernist techniques, and started a faction opposed to Cormon's teaching. Lautrec seems to have been negatively rather than positively influenced by them; he lost faith in academicism but never showed any interest in theorizing or joining a particular school or movement. He drew on whatever seemed nourishing – in Forain, in Degas, in Japanese art – and quietly developed his own individual style. In the event, he proved wiser than his friends. Anquetin, for whom everybody predicted a great career, underwent radical changes of style and technique before falling back on a factitiously vigorous neo-academicism; Bernard made a honourable contribution to artistic ideas, strongly influencing Gauguin in particular, but his own painterly impulse flagged and he too finally turned to the past and embraced a sterile 'neo-classical' style.

Vineyard at Céleyran.
1881. Musée
Toulouse-Lautrec,
Albi.

Lautrec's portrait of Bernard (1885) is perhaps the most satisfactory of his paintings from this period of uncertain development; it is a straightforward but sensitive work, touched with obvious feelings of youthful camaraderie. Bernard,

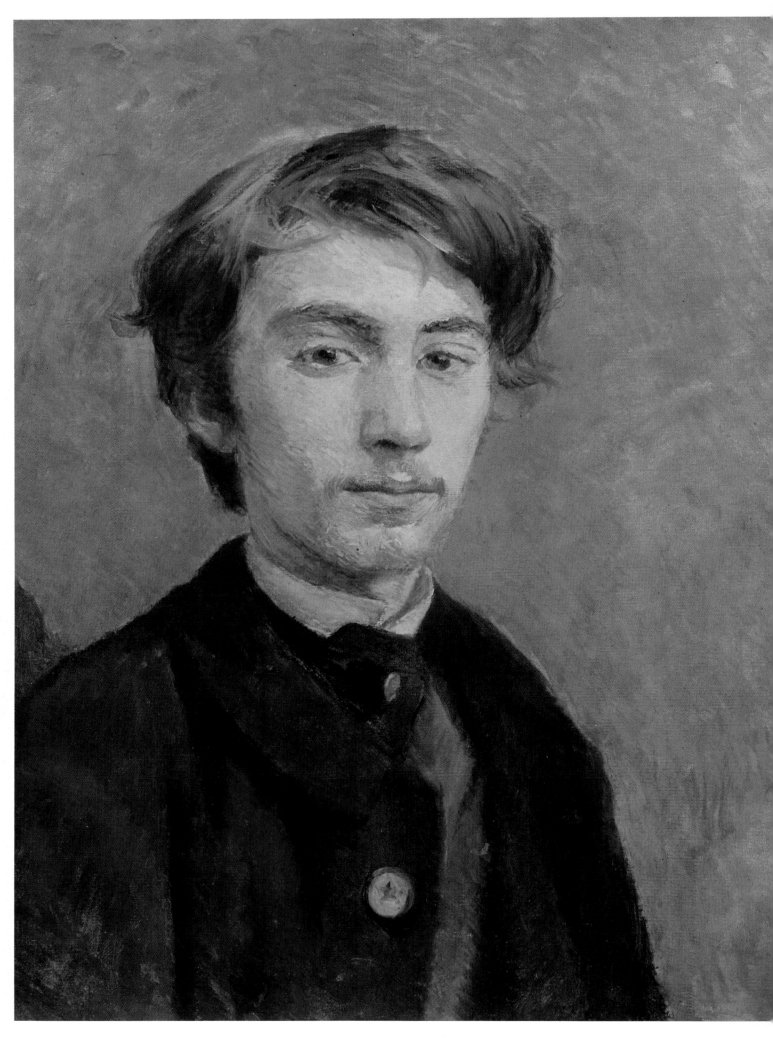

Anquetin and other friends from Cormon's studio influenced Lautrec most deeply of all by introducing him to the delights of Montmartre, which soon drew him so strongly that he decided it was time to leave home. His family disapproved and refused to rent a studio for him, but he settled in the area as a lodger at the house of René Grenier, a gentleman-amateur painter he had met at Cormon's. Later on he moved in with Henri Rachou, his oldest friend from the teaching studios, who has left us a touching portrait of Lautrec as he was a couple of years earlier, at the age of nineteen, in which he is still an unmistakably callow and rather earnest-looking youth. Grenier and his ex-model wife Lily loved parties and entertainments, and in their company Lautrec indulged his penchant for dressing up; photographs show him as a Spanish senorita on Grenier's arm, as a chorister, a muezzin, a Japanese. He visited the Moulin de la Galette, high up the Butte on the Rue Lepic, but found that dance-halls were less to his taste than professional entertainments; at the Elysée-Montmartre he could sit drinking steadily for hours while making one sketch after another of the performers he later immortalized – two young girls nicknamed La Goulue and Grille d'Egout, and their male partner, an old trouper with long india-rubber limbs known as Valentin le Désossé ('Boneless Valentin'). He also frequented the Chat Noir, where Rodolphe Salis compèred a literary-artistic cabaret in the midst of a rather plush pseudo-medieval décor with waiters running about in fancy dress to serve the establishment's bad beer.

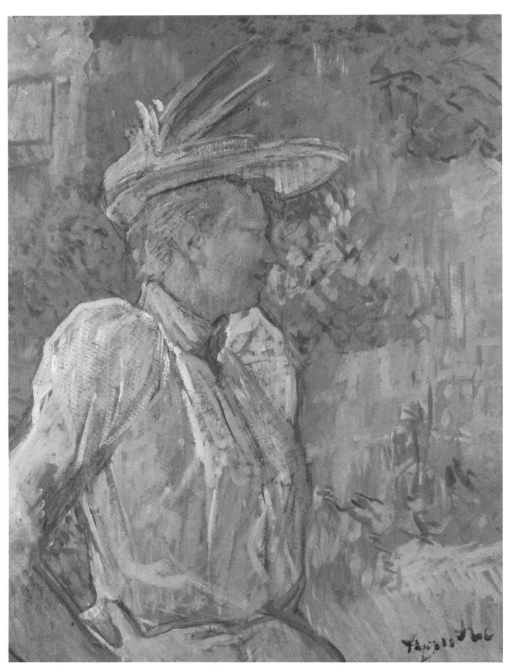

The Dancer Gabrielle.
1890. Musée
Toulouse-Lautrec,
Albi.

When Salis and the Chat Noir moved from the Boulevard de Rochechouart, his premises were taken over by Aristide Bruant, whose cabaret Le Mirliton was even more to Lautrec's liking. Bruant replaced Salis's bohemian-intellectual bombast with a rough proletarian style. He dressed as Lautrec was so often to portray him in lithographs and posters, in a broad-brimmed black hat, flaming red scarf, black corduroy jacket or heavy cape and tough workmen's boots; he carried a heavy stick whose only imaginable function was as a weapon; and he scowled and frowned and insulted his customers between thrilling performances of songs devoted to the sorrows of the 'submerged tenth' – broken-down prostitutes, pimps, gangsters and tramps, doomed to starvation, disease, the prison and the hospital. Although Bruant drew on his own experiences for his songs, lacing them with Parisian argot, he too was catering for genteel thrill-seekers; most of his audience was 'slumming' just as Salis's had been 'bohemianizing'. All the same, Lautrec was delighted with the Mirliton; he became a regular customer and a crony of Bruant himself, whose songs he sang every morning in front of his easel at Cormon's. The Mirliton, like the Elysée-Montmartre, inspired a painting by Lautrec, who had begun to realize the possibilities of this night-world as a subject for his art. However, at this time his drawing was still more adventurous than his painting, and the appearance of his sketch *Gin Cocktail* in the Montmartre magazine *Le Courier Français* (September 1886) may be called the first public recognition of his abilities. It was soon to be followed by the *Louis XIII Chair* and other illustrations for the *Mirliton*, a little magazine published by Bruant. Since Lautrec did not sell his first canvas until 1889, it is not surprising that he came to regard illustrating as a completely legiti-

mate form of artistic expression – an attitude that later led to his fruitful involvement with the art of the poster.

In Montmartre, where the women were uninhibited or unprejudiced or mercenary – and often all three – Lautrec acquired a good deal of sexual experience; by all accounts he was singularly well equipped to give satisfaction, and acquired the nickname 'coffee pot' in reference to his profile. His longest-lasting relationship was with an ex-laundress named Marie-Clémentine Valadon who had taken up modelling. Though still only in her teens, she had a powerful, untamed personality; she had already borne a son whose father may have been Puvis de Chavannes, a Spaniard named Utrillo, or some other party, and for several years she had an on-off relationship with Lautrec, who painted two interesting portraits of her. According to one account, he broke with her (in 1888) after he discovered she had faked a suicide attempt as part of a scheme to make him marry her. She seems not to have confided her artistic ambitions in him – she drew constantly, and did eventually, as Suzanne Valadon, become a considerable painter. Her son, Maurice Utrillo, also became famous – like Lautrec, as a painter of Montmartre. But his was not the Montmartre of music-halls and cabarets, but the windswept Butte of tree-lined streets that lay behind the boulevard night-spots.

The last friend Lautrec made at Cormon's was a Dutchman in his thirties, Vincent van Gogh, who arrived in the spring of 1886. The contrast between the earnest, passionate Dutchman and the jovial, worldly, anti-ideological Lautrec could hardly have been greater, yet the two men got along well and, with Anquetin and Bernard, formed a sort of group; artistically they had little in common, but mainly on Van Gogh's initiative they arranged joint exhibitions at various Montmartre restaurants over the following year or so. For Lautrec this was a time of liberation; at the end of the summer of 1886 his parents had allowed him enough money to rent a studio of his own, and he had arranged to share a flat with an old friend, the medical student Bourges – a very useful friend too, when Lautrec, inevitably, caught syphilis a couple of years later. Both studio and flat were, of course, in Montmartre.

In February 1888 Lautrec exhibited at the 'Les Vingt' show in Brussels, and in the following year with the Salon des Indépendants; these were the two most important of the independent exhibiting associations that had sprung up in the wake of the revolutionary Impressionist shows. Later in 1888, Van Gogh left for Arles, where he was to be joined by Gauguin. Lautrec was to see him only once again, after Van Gogh had quarrelled with Ganguin and experienced a breakdown during which he cut off part of his ear. He was still in medical care at Auvers, outside Paris, when he lunched with Lautrec in July 1890; on 27 July 1890 he shot himself in a field where he had been painting, and he died two days later.

Meanwhile, in 1888–89, Lautrec had begun to find his own style and produce his first really significant works.

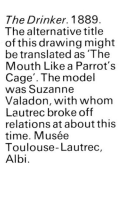

The Drinker. 1889. The alternative title of this drawing might be translated as 'The Mouth Like a Parrot's Cage'. The model was Suzanne Valadon, with whom Lautrec broke off relations at about this time. Musée Toulouse-Lautrec, Albi.

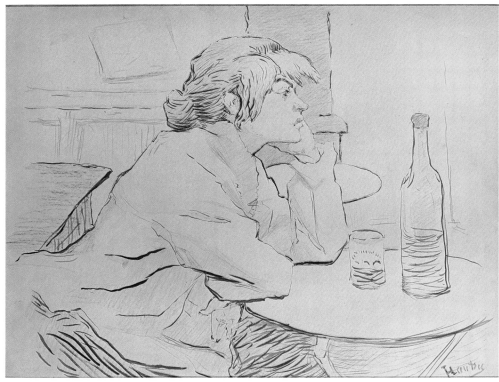

The Best Years

By 1888 Lautrec was working fairly regularly as an illustrator for magazines, and his drawings of this period are about as close as he ever came to social criticism. Slight and temporary as it was, this tendency perhaps owed something to the influence of Bruant and Van Gogh. Among Lautrec's drawings for *Paris Illustré*, for example, is a scene showing an extra trace horse being attached to an omnibus to haul it up the steep Rue des Martyrs and on to the top of the Butte; the tough, clumsy-looking little working horse is a far cry from the thoroughbreds Lautrec had sketched and painted in his boyhood. A more satirical note is struck in *First Communion Day*, which also exists in the form of a pleasantly sketchy little painting; it shows a middle-class family trooping rather glumly along the pavement, the husband pushing a pram with a baby in it, followed by his daughter in her communion dress, while his large wife brings up in the rear with a second daughter. The model for the tall, gaunt husband was François Gauzi, a fellow painter from Toulouse whom Lautrec had met at Cormon's. They now became close friends and boon-companions, and Gauzi twice sat for Lautrec. Gauzi was the source for the story of Valadon's fake suicide and many other anecdotes, told in the reminiscences of Lautrec he published in 1954.

First Communion Day. 1888. A mildly satirical painting of bourgeois family life. It was done as a preparatory sketch for a drawing that appeared in the magazine *Paris Illustré*. Musée des Augustins, Toulouse.

Portrait of François Gauzi. 1888. Gauzi was a fellow-painter from Toulouse, in Lautrec's part of the country, and became a close friend. In old age he wrote an interesting memoir of Lautrec. Musée des Augustins, Toulouse.

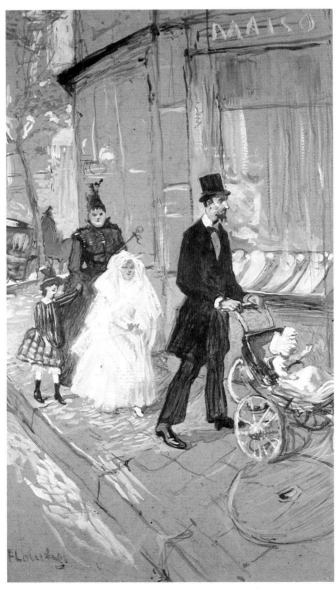

Portrait of Hélène Vary. 1888. Kunsthalle, Bremen.

Lautrec was also painting furiously. He made numerous portraits of women, ranging from Red Rosa, the prostitute who gave him syphilis, to Hélène Vary, a young neighbour who posed for him on several occasions. The well-known portrait of her in the Kunsthalle, Bremen, was largely executed from a photograph, a method that Lautrec often used in preference to working long hours with an increasingly jaded model. The photograph of Hélène Vary survives, as do several such 'models'. They demonstrate that Lautrec normally achieved a convincing likeness and almost never glamorized his subjects; if anything, he made them rather more interesting and less good-looking than they actually were. However, on occasion he was tempted to caricature them, especially if they were public entertainers and so (perhaps) fair game.

His tendency to caricature was particularly strong in 1888–89, when he was moving away from his earlier realism. The *Equestrienne at the Cirque Fernando* was

37

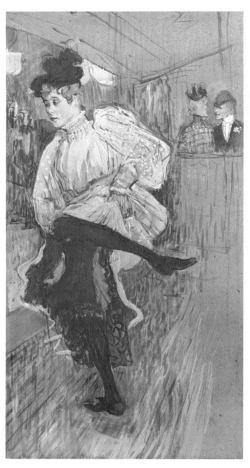

a large, ambitious canvas, originally inspired by the bare-backed rider, a young woman of good family who had adopted her profession after running away with her riding-master. Lautrec made many studies of her, yet the final painting is dominated by the moustachioed, whip-cracking figure of Monsieur Loyal, the ring-master. The use of almost flat, bright colours and bold 'cut-offs', combined with the powerful sense of movement, marks a significant advance towards Lautrec's distinctive style. However, he had yet to achieve a satisfactory compromise between realism and caricature; the cartoon-like quality of the *Equestrienne* must have dissatisfied him, and he swung back to a relative realism in his next ambitious canvas, the *Dance at the Moulin de la Galette* (1889; Art Institute of Chicago). A decade or so earlier, Renoir had chosen to paint a sunny outdoor picture of dancing at the Moulin de la Galette; Lautrec, characteristically, prefers night-time and indoors. The atmosphere is rather drab, with dancing couples whose clumsy movements are skilfully suggested, and 'wallflowers' who look like working girls rather than ladies of the night on the prowl. This is not a glamorous night-spot like the later Moulin Rouge, but a place where ordinary men and women – clerks and soldiers and shopgirls – come in search of romance. In the foreground are the plain wooden tables; the one closest to us is empty, but the evidence remains – a pile of saucers, the French waiter's way of counting how many drinks a customer had been served.

The painting is executed in a manner Lautrec made his own, built up with large brush-strokes like the hatching or shading of a drawing. The *Dance at the Moulin de la Galette* is a canvas, but Lautrec had already discovered how effectively his method could be used on cardboard. The idea was not his own; he borrowed it from Degas' friend Jean François Raffaëlli, who had exhibited with the Impressionists and painted working-class subjects with considerable skill and rather too much sentiment. When the paint, already thinned with spirit, was applied to the cardboard, it was partly absorbed, giving a flat, grainy quality quite distinct from the richness and heaviness of the traditional oil painting on canvas. The technique was eminently suited to Lautrec's genius as a draughtsman, and he made increasing use of it, though without ever entirely abandoning painting on canvas. He also exploited more and more the colour and quality of the cardboard itself, allowing it to

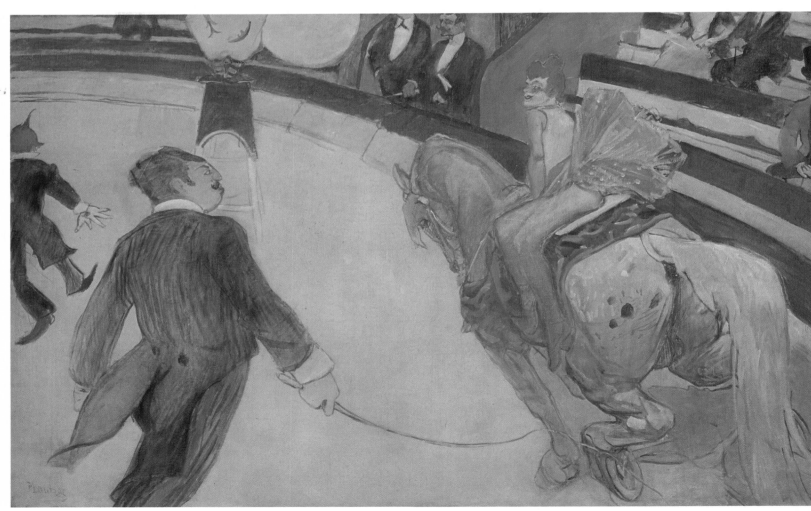

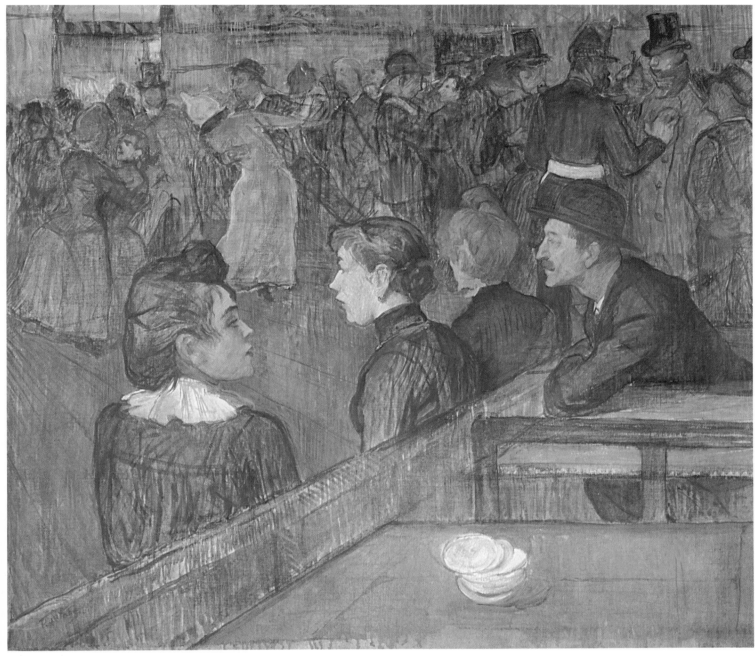

show through the paint or leaving large areas unpainted; the culmination of this technique can be seen in such masterpieces as *Jane Avril Dancing* and *Woman in a Black Feather Boa* (both 1892).

For Lautrec, the greatest event of the year 1889 was the opening of the Moulin Rouge music-hall, specially built on a vacant site on the Boulevard de Clichy. This was a considerable distance from the hub of Montmartre night-life, the area around the Elysée-Montmartre and the Mirliton at the far end of the adjoining Boulevard de Rochechouart. The Moulin Rouge was trespassing on the more respectable territory just below the Montmartre cemetery, where a number of well-established artists lived or worked; Lautrec's old teacher Fernard Cormon had his studio only a few doors away from the new music-hall. The owners of the Moulin Rouge, Joseph Oller and Charles Zidler, evidently intended to give their new venture an air of distinction not possessed by their rivals.

There was no windmill on the spot, despite the name, but an illuminated red mill, erected on the roof as a sign, did duty for the real thing. The large main room, where the public entertainment took place, was more grandly decorated than any other place in Montmartre. It was lined with gilt-framed mirrors and lit by bronze-cased lamps; a promenade ran round the room at ground level, while a gallery above it afforded a more lordly view of the proceedings. Outside was a garden, ideal for tête-à-têtes, where meals and drinks were served in good weather, with a little stage, a life-size papier-mâché model of an elephant, monkeys on chains, and facilities for donkey-rides. Oller and Zidler even lured away the stars of

the Elysée-Montmartre as part of this ambitious effort to put the Moulin Rouge in a class of its own. They succeeded so completely that today it is the only one of Montmartre's popular entertainments that is generally remembered. The Moulin Rouge was a huge success from the first night. It attracted people of all conditions, but especially people with money; and it was not without high-society patrons including, on occasion, the Prince of Wales (later King Edward VII), the British royal playboy and leader of the international set.

Lautrec and his friends were there on the first night, 5 October 1889, which marked the beginning of a love affair between the painter and the music-hall that lasted for several years. Lautrec made the Moulin Rouge and its stars immortal by painting them again and again; but his passion was not unrewarded. From being virtually unknown, he became famous as the historian of the place. His *Cirque Fernando* was hung in the foyer and other works by him were often exhibited there; his large canvas *Dance at the Moulin Rouge* (1890) was quickly bought by Oller and hung in the place of honour (over the bar); and his superb poster for the Moulin made his name known all over Paris.

There is one unmistakable figure in the *Dance at the Moulin Rouge* – the tall, cadaverous, top-hatted Valentin le Désossé ('Boneless Valentin'), a genius of the dance whom Lautrec drew and painted many times. Valentin had had a long career even before appearing at the Elysée-Montmartre and then going on to the Moulin Rouge; by 1889 he was approaching fifty, but he seemed ageless if, at first sight, singularly unattractive for a music-hall performer. Yet despite his awkward look and big feet, Valentin was a superb dancer, supple-limbed and with an impeccable sense of rhythm; contemporary descriptions of his whirling waltzing bring to

Below: *Portrait of Monsieur Fourcade*. Museo de Arte, Sao Paolo.

Right: *Woman in a Black Feather Boa*. 1892. Musée du Louvre, Paris.

Far right: *Portrait of Justin Dieuhl*. 1890. Musée du Louvre, Paris.

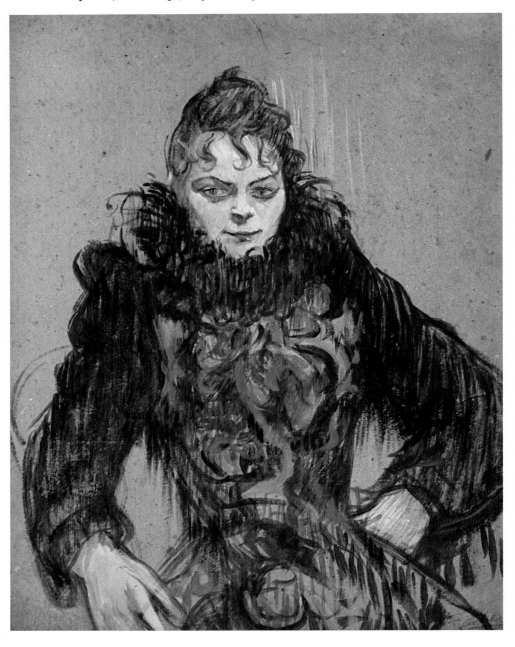

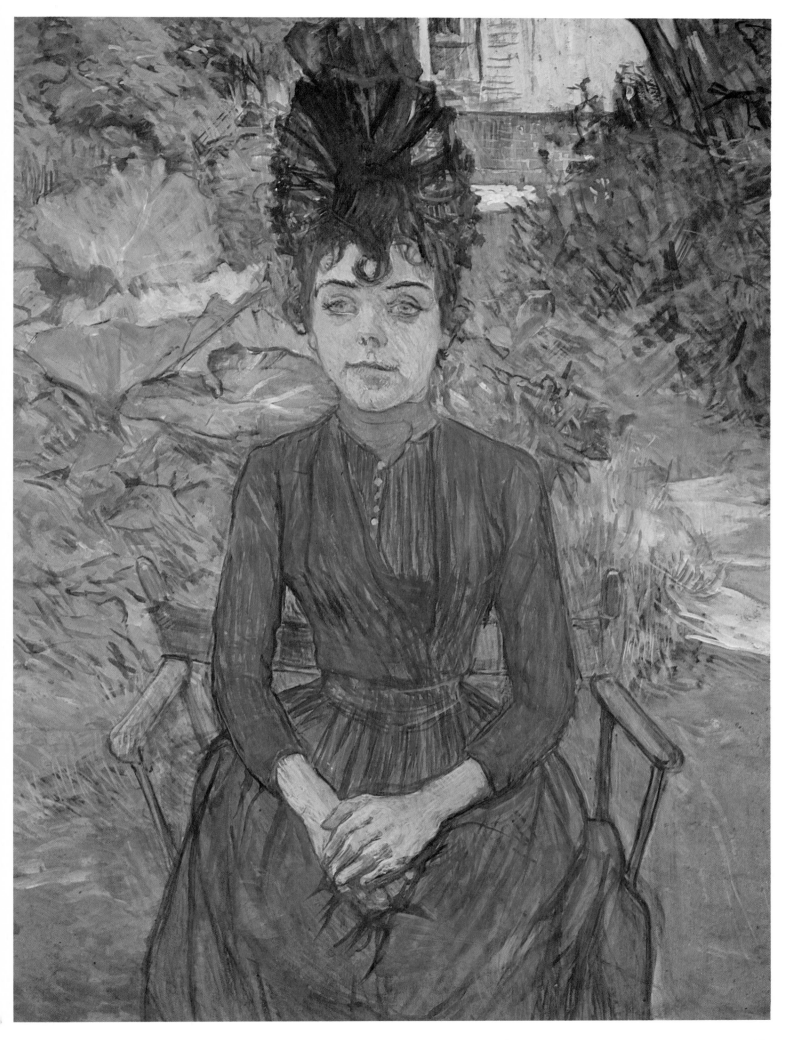

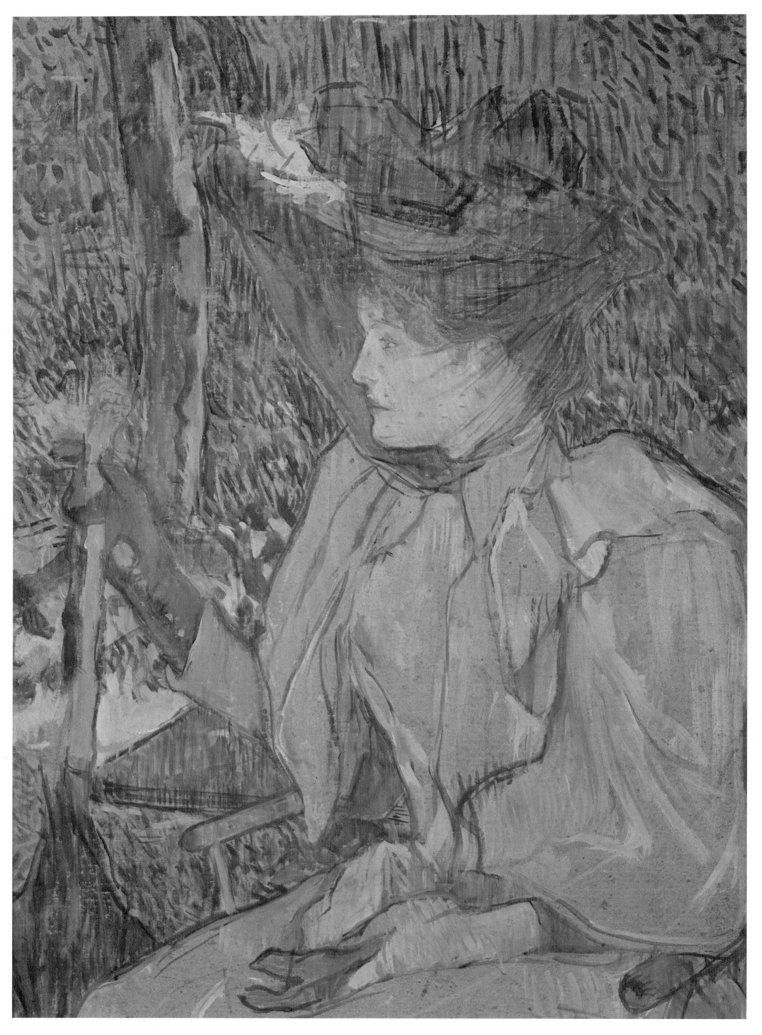

mind the film performances of Fred Astaire. Valentin seems to have led a curious and satisfactory double life, working as a respectable wine merchant or lawyer's clerk during the daytime. His physical energy must have been phenomenal.

However, in this period female dancers were the supreme stars, perhaps because they could make a more open display of their sexual allure. Valentin had discovered and trained a young girl from Alsace called Louise Weber, whom he partnered at the Elysée-Montmartre and took with him to the Moulin Rouge. She was known as La Goulue, 'The Glutton', in reference to her enormous appetite and her habit of emptying any glass in sight. She was vulgar, bad-tempered and incredibly foul-mouthed. But she had a full figure, a small waist, beautiful legs, a mass of fair hair wound up into a top-knot, and, in dancing the quadrille, the zest and energy to kick ever higher and higher; she also possessed an all-pervasive sexual insolence that held audiences and kept them agog for a glimpse of the bare thigh above her garter or the little heart embroidered on the back of her drawers. As though sated with charm and delicacy, the crowds at the Moulin Rouge revelled in this frenzy and expressed their delight in a performer who never gave them a smile or acknowledged their admiration, and sometimes coarsely abused them. (Given the licensed behaviour of such 'gutter' performers as Bruant and La Goulue, and the frequency with which – in both literature and life – men ruined themselves for 'fatal women' who openly despised them, there was clearly an odd streak of masochism in the late 19th-century gentleman that has never been satisfactorily explained.) At the Moulin Rouge, La Goulue blossomed into a great star, overshadowing Grille d'Egout, La Môme Fromage, Nini Patte-en-l'air ('High-hoofing Nini') and the rest of the team from the Elysée-Montmartre. By 1891, when Lautrec was commissioned to design a poster for the Moulin Rouge, La Goulue was the only performer named on it.

The importance of this poster can hardly be exaggerated. The acknowledged master of the technique was Jules Chéret, whose compositions expressed a self-consciously innocent gaiety with a good deal of frilly charm. Chéret had designed

Left: *Portrait of Honorine P.* 1890. Musée du Louvre, Paris.

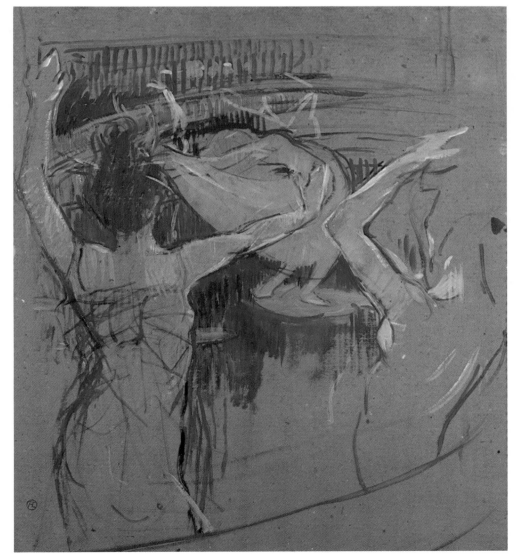

Left: *The Ballet 'Papa Chrysanthème'.* 1892. Lautrec's painting records a Japanese fantasy staged at the Nouveau Cirque (New Circus). Musée Toulouse-Lautrec, Albi.

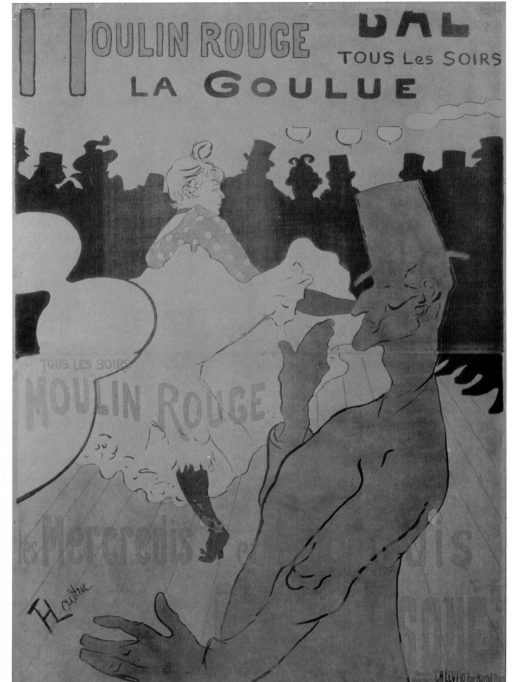

Right: *Moulin Rouge: La Goulue*. 1891. The first and most famous of all Lautrec's posters, celebrating the music-hall and dancers that gave him so many subjects. Musée Toulouse-Lautrec, Albi.

Above: *Moulin Rouge: La Goulue and Valentin*. 1891. A sketch for the famous poster. Musée Toulouse-Lautrec, Albi.

the poster for the opening of the Moulin Rouge, so Lautrec's commission set him in direct competition with the established master; and his success meant recognition as the outstanding French poster artist, as well as the satisfaction of seeing his work on billboards and booths all over Paris. Lautrec realized that the essence of the poster was a bold simplicity that caught the attention and conveyed its message instantly, before the passenger was carried past by his omnibus or carriage, or the pedestrian was distracted by some other sight in his busy city. The *Bal au Moulin Rouge* owes its bold outlines and large areas of flat colour to the influence of the Japanese print, but its caricatural quality and emphasis on significant detail were Lautrec's own. The written message is to the point: 'Moulin Rouge – Every Night – La Goulue!' The high-kicking dancer is shown as if in a spotlight, her white underwear flaring like a large blossom in the centre of the picture. The audience, gathered behind her in a semi-circle, are no more than a line of silhouettes that might have been cut out of black paper; but their toppers and hats with waving plumes, set at a variety of angles, give the picture much of its splendid sense of movement. Right in the foreground, but reduced almost to a silhouette, is Boneless Valentin in unmistakable (and bony) caricature. The result is a masterpiece of design, as remarkable for its eliminations as for its emphases, carried out in the simple four-colour lithographic printing process of the time.

Having discovered its advantages, Lautrec was to work extensively with lithography to the end of his life. Posters form quite a small proportion of his output, although their number includes some of his masterpieces, such as *Aristide Bruant at the Ambassadeurs*, *Le Divan Japonais* and *Jane Avril at the Jardin de Paris*. He also executed book covers and menus, as well as non-functional lithographs in both colour and black and white such as *Elles*, a series of studies of women issued in 1896. And in addition there are the quantities of preparatory drawings he made for lithographs and posters, plus paintings on cardboard – works of art in themselves – that represent a final try-out before the execution of the design on the lithographic stone. Although many of Lautrec's contemporaries looked on him as an aristocratic dilettante, his printers quickly came to appreciate his professionalism; when there was work to do, he arrived early in the morning – usually in his evening clothes and perhaps straight from some debauch, but quite capable of working all day with complete concentration.

He was at his most prolific in the early and middle '90s. Determined not to behave like an amateur or ivory-tower artist, he worked hard as an illustrator; but he also continued to turn out paintings, and to exhibit wherever and whenever

Below: *Aristide Bruant at the Ambassadeurs*. 1892. It is interesting to compare this painting with the much bolder and more simplified poster on the same subject (left). Musée Toulouse-Lautrec, Albi.

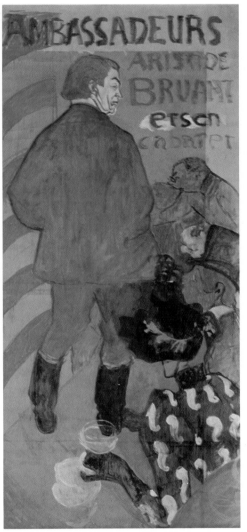

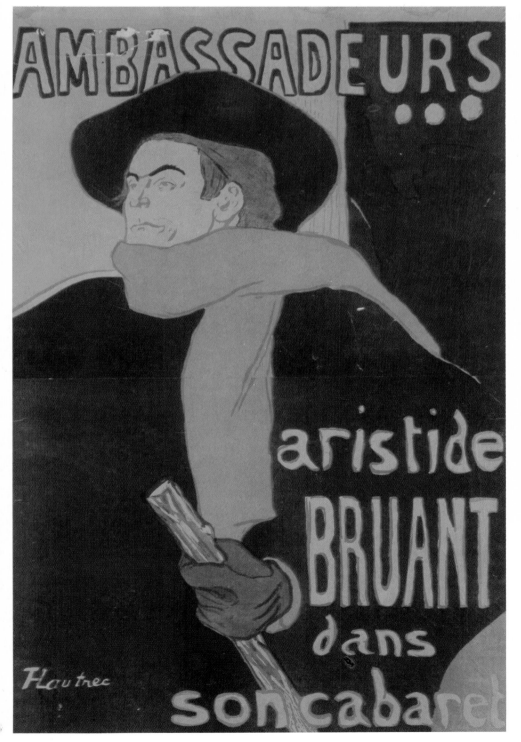

Left: *Aristide Bruant at the Ambassadeurs*. 1892. The manager of the Ambassadeurs was so outraged by this poster that he refused to use it; but Bruant made him change his mind by threatening to cancel his appearance. Musée Toulouse-Lautrec, Albi.

45

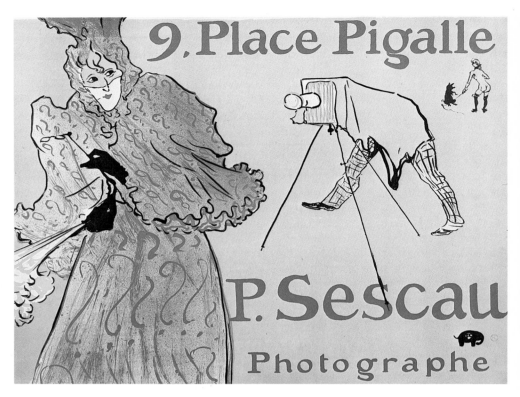

Right: *Sescau the Photographer*. 1894. Sescau was a close friend of Lautrec. This poster advertises his photography business in Montmartre. Musée Toulouse-Lautrec, Albi.

Above: *Portrait of Dr. Gabriel Tapié de Céleyran*. 1894. Lautrec's cousin and close friend for the last nine years of his life. Through Tapié Lautrec was able to attend operations, performed by the celebrated Dr. Péan, which provided the subjects for several works. Musée Toulouse-Lautrec, Albi.

possible. At this time, painting was regarded as a serious or 'fine' art, whereas a poster was merely popular and 'applied' (that is, functional), so his reputation as a poster artist did not give him a great position in the art world; that was still to be laboriously earned. Painting and designing all day, drinking and drabbing and drawing most of the night, living on catnaps and cocktails – for a few years, at least, Lautrec seemed capable of thriving on a mode of life that might have destroyed a physically better-endowed man.

He had collected a circle of friends and drinking companions that ensured he was never alone when he was not working. René and Lily Grenier, the couple with whom he had lodged, were still much in evidence, involving Lautrec in practical jokes, fancy-dress parties and fairly innocuous scrapes of the sort traditional among students. Of his painter friends, Gauzi and Anquetin often accompanied him to the Moulin Rouge and other night-spots. Dr Henri Bourges, his flatmate, appeared occasionally, though much of his time seems to have been spent in attempts to restrain Lautrec's self-destructive drinking. An influence in the opposite direction was Maurice Guibert, a champagne salesman who was said to have a wider range of acquaintance among the shady ladies of the town than any other man in Paris. He has often been blamed for leading Lautrec astray, but the truth is that Lautrec wanted to be led astray, finding amusement, self-forgetfulness and interesting material in the bars and brothels to which Guibert took him; he had a 'revenge' of sorts by using Guibert as the model for the broken-down debauchee in *A la Mie* (1891; Museum of Fine Arts, Boston). Among Guibert's friends who also became Lautrec's was the photographer Paul Sescau, for whose studio in the Place Pigalle the artist later (1894) made an entertaining poster. And then there was Maxime Dethomas, a being so tall that Lautrec called him 'the big tree'; Dethomas was a shy, quiet man whom Lautrec was to bully into sharing his periods of residence in the brothels.

An aspect of Lautrec's psychology that is not difficult to understand is his delight in the company of tall men who would allow themselves to be tyrannized. The perfect slave appeared on the scene in 1891. He was the painter's cousin, Gabriel Tapié de Céleyran, whom he had known since childhood and who had more recently fallen completely under Lautrec's spell during a family holiday in the south. Tapié came to Paris in order to finish his medical studies, and at once became Lautrec's inseparable companion of the night. He was tall and stooped, awkward, solemnly self-important, and adorned with pince-nez, side-whiskers and a large, pimply nose, all features that can be discerned in Lautrec's highly successful portrait of his cousin standing in the foyer of the Comédie-Française (1894). Lautrec was enchanted with Tapié's absurdity, his utter docility, the imperturbability with which he passed through the wildest nights, and even his name, which lent itself to the most elaborate puns.

46

These and other friends were often sketched by Lautrec and sometimes made the subjects of portraits. They also appear often in crowd scenes that we assume to be anonymous because the convention of portraiture is that the subject should occupy a prominent position in the painting. *At the Moulin Rouge* (1892; Art Institute of Chicago), for example, shows an apparently casual group round a table, drinking and conversing, and other customers wandering about, but the group in fact consists of Sescau, Guibert, a dancer called La Macarona and the yellow-bearded critic Edouard Dujardin; in the background, La Goulue is fixing her hair in the mirror while the tall, round-shouldered Tapié and the diminutive Lautrec walk away together.

Indirectly, the tragedy of Vincent van Gogh brought another friend into Lautrec's life. In January 1890 he had made a trip to Brussels with Guibert to see the Les Vingt exhibition, where both his and Van Gogh's works were on show; while there he became involved in an argument over the merits of Van Gogh's work – savagely attacked by an artist named de Groux – that almost led to a duel. A few months later Van Gogh was dead, and in October his brother Théo, to whom he had been very close, suffered a mental collapse and died shortly afterwards. Théo had been the manager of the Galerie Boussod et Valadon, where he had tried to sell the works of his brother and other avant-garde artists (including Lautrec) as well as those of the more popular and 'respectable' painters. His place was taken by none other than Maurice Joyant, Lautrec's childhood friend from the Lycée Condorcet. When Lautrec turned up at the gallery, the friendship was renewed. It lasted to the end of the painter's life, and was of special value to him both personally and professionally. Joyant made one effort after another to persuade his friend that he was killing himself (which Lautrec doubtless knew already but did not care to do anything about); he also took practical action by carrying him away from Montmartre for yachting weekends and cross-Channel trips that allowed his much-

Aristide Bruant Riding a Bicycle. 1892. Musée Toulouse-Lautrec, Albi.

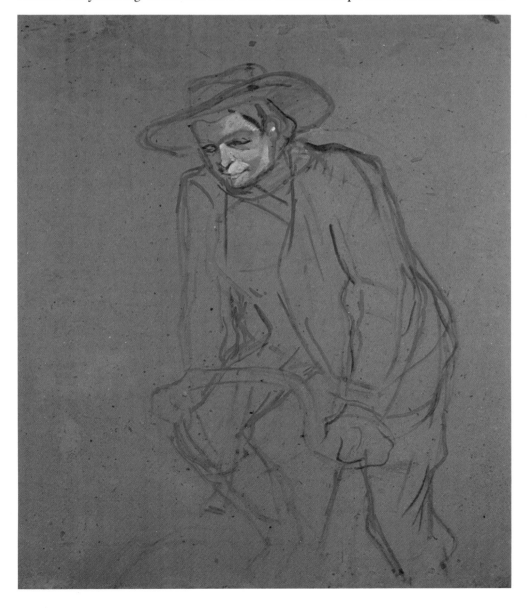

abused constitution to recuperate, and so probably prolonged his life. As manager of Boussod et Valadon, and afterwards as co-proprietor of his own firm, Joyant pushed Lautrec's work and arranged for exhibitions whenever possible. However, contemporary reactions to Lautrec the artist were not virulently hostile but simply tepid; he was regarded as a talented follower of Degas with an excessive taste for sordid scenes that was more acceptable in his work as an illustrator (licensed to make sharp comments on the fashions and manners of the day) than in a 'true artist'. Despite all his efforts, Joyant never succeeded in shaking this view of Lautrec, any more than he succeeded in shaking Lautrec's attachment to absinthe and cocktails.

Perhaps the most respectable of Lautrec's friendships was with a middle-aged family group that lived quietly in a flat just off the Place Pigalle. The Dihau family, two brothers and a sister who had all made careers in music, were distant relatives of Lautrec's, and in 1890–91 he painted portraits of all three. Marie Dihau gave piano lessons, and Lautrec's portrait (1890) shows her at the keyboard. Désiré Dihau played the bassoon in the orchestra at the Paris Opéra, and also composed songs that were performed at the Moulin Rouge and other places of popular entertainment. He is shown in the front row of Degas' *Musicians of the Orchestra* (*c*.1868–69); Degas had perhaps been in love with Marie at about the time he painted it, and had remained a friend of the family ever since. The Dihaus arranged

Mademoiselle Dihau Playing the Piano. 1890. Painted in the dining room of the Dihau's apartment. The family were friends of Degas, whom Lautrec admired intensely; and *Musicians of the Orchestra* and other paintings by Degas hung on the walls. Musée Toulouse-Lautrec, Albi.

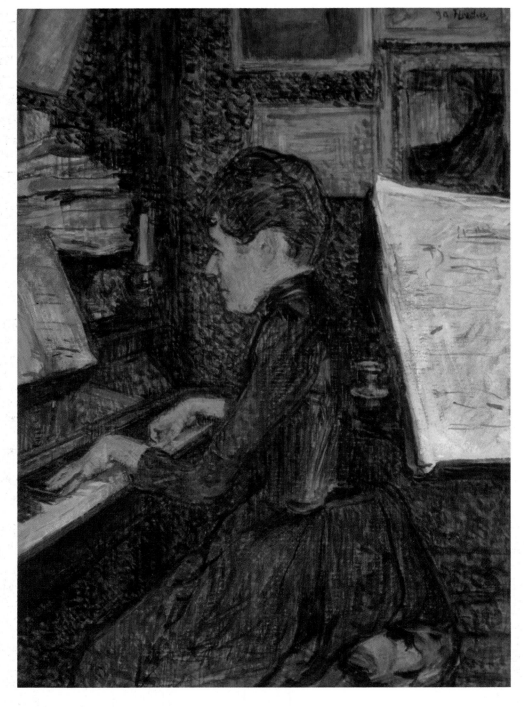

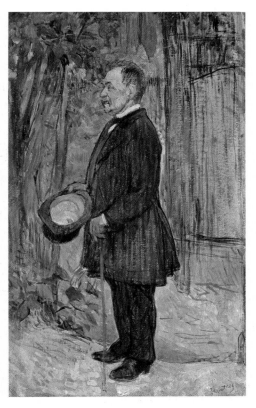

a meeting between Lautrec and Degas, who seems to have been polite and encouraging but did not invite intimacy. His few reported comments on Lautrec are contradictory, from the admiring 'To think this has been done by a young man when we have worked so hard all our lives!' to the pointedly cruel 'He wears my clothes, but cut down to his own size'. Given Degas' cantankerousness, both quotations may well be correct. Lautrec's portrait of Désiré Dihau (1891) looks like a conscious tribute to Degas; in an arrangement particularly reminiscent of the master, the subject, shown reading his newspaper in a garden, occupies the lower left-hand area of the picture and has 'lost' his legs.

The portrait of Henri Dihau (1891) is more conventional. He is shown in the same garden as his brother – a garden just behind the Boulevard de Clichy that belonged to a retired ex-photographer called Père Forest; it was, in fact, the garden Lautrec had been using for years whenever he wanted an open-air background to a painting. By contrast with Monet, who would paint a scene many times in order to capture its changing appearances in different lights, Lautrec used the same background through indifference to nature, which for him could never be more than a setting for the endlessly interesting depiction of human beings,

The pattern of Lautrec's life had now formed, and persisted almost to the end: work and the night life, with occasional holidays by the sea, in the country with his family or abroad. In 1893, when Bourges married and Lautrec had to find somewhere to live, his mother rented apartments in the Rue de Douai, just below the Boulevard de Clichy, and made a home for him; but despite her presence Lautrec's existence continued to be as irregular as ever.

For a couple of years Lautrec was obsessed with the Moulin Rouge. He produced paintings such as *La Goulue Entering the Moulin Rouge* (1892; private

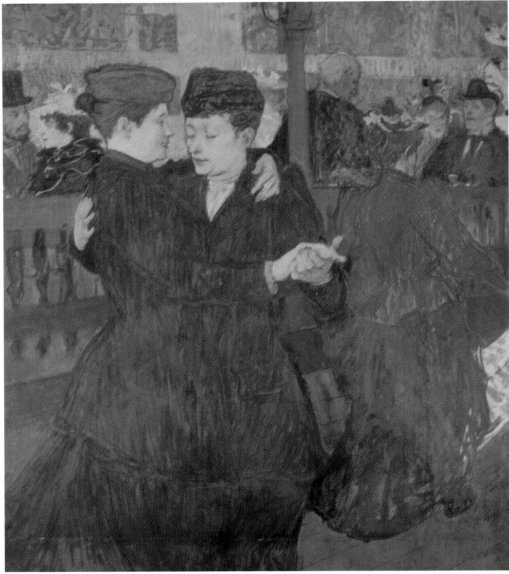

Right: *The Two Waltzers*. 1892. A scene from the Moulin Rouge. An early example of Lautrec's obsessive interest in intimate relationships between women. The figure on the right is the female clown Cha-U-Kao, whom he depicted several times in later years. National Gallery, Prague.

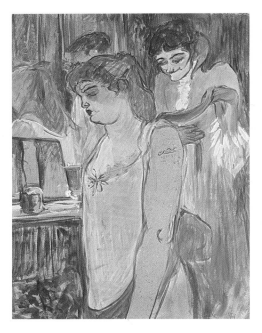

Above: *Woman with a Tattoo*. 1894. Musée Toulouse-Lautrec, Albi.

Far right: *Nude*. 1893. Study for a lithograph. Musée Toulouse-Lautrec, Albi.

collection, New York) and the *Two Waltzers* (1892), lithographs such as the splendid *Englishman at the Moulin Rouge*, and many other works. Performers other than La Goulue and Valentin began to attract his attention. The first of these was Jane Avril, a dancer in her early twenties whose appeal was as firmly based on her ladylike delicacy as La Goulue's was on an all-conquering strident vulgarity. Lautrec saw Jane Avril first at the Moulin Rouge, where she was promoted to a solo spot but made little impression on audiences used to coarser fare. Instead of high kicks and flashes of thigh, she developed a style involving intricate side-kicks and leg-work which Lautrec evidently tried to capture in *Jane Avril Dancing*. In performance she seems to have displayed a kind of intense nervous energy rather than animal vigour; she was frail, with turquoise eyes and a long pale face that was only sometimes beautiful, and she emphasized the lack of resemblance between herself and the other Moulin Rouge dancers by designing her own costumes in subtle harmonies quite unlike the crude, vaguely 'underworld' garb of the others. This passion for refinement was more than a gimmick or a stage style; having barely survived a terrible childhood with a violent, half-mad mother, Jane Avril seems to have developed a genuine horror of the brutal side of life. She worshipped not only refinement but culture, and acquired enough of it to impress the writers and artists – Lautrec among them – who became her admirers even before she had a wider vogue.

Jane Avril and Lautrec became great friends, and in 1892–93 he made her the subject of many studies and several major works. As well as *Jane Avril Dancing,* he painted *Jane Avril Leaving the Moulin Rouge* (Wadsworth Athaneum, Hartford, Connecticut) and *Jane Avril Putting on Her Gloves* (both 1892). In his poster of 1892 for the Divan Japonais, she is at the very front of the picture, dominating the design in her elegant black outfit. The performer, Yvette Guilbert, is recognizable only by her long neck and black gloves; her head is cut off, in the style of Degas, by

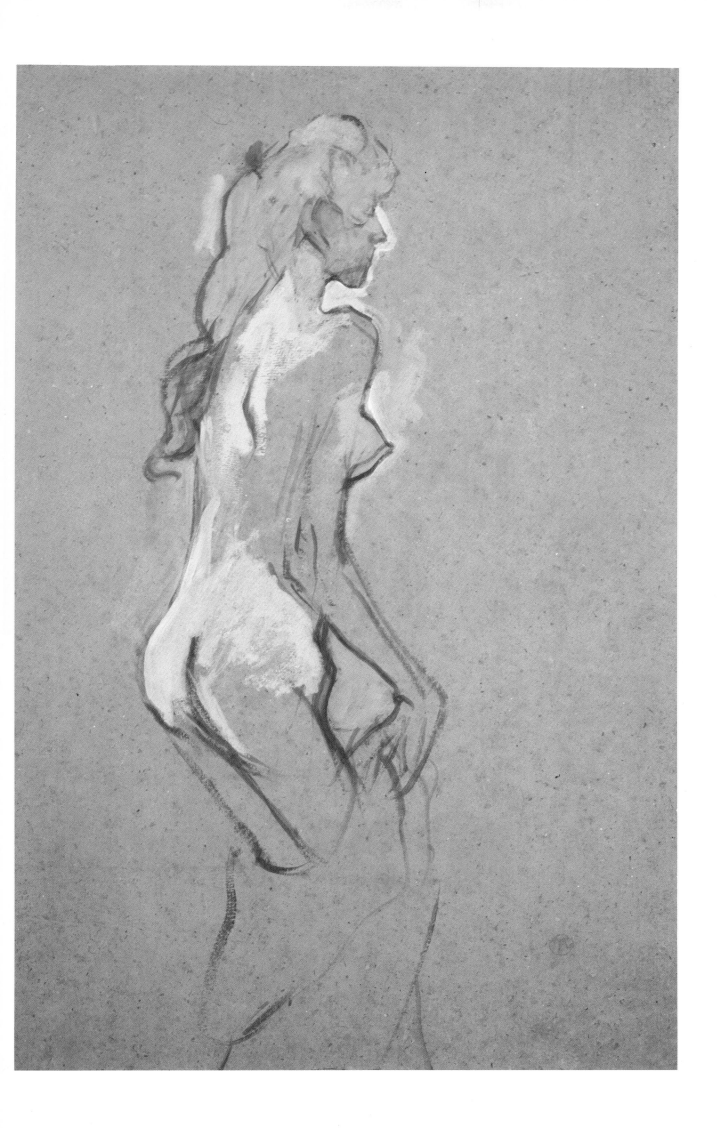

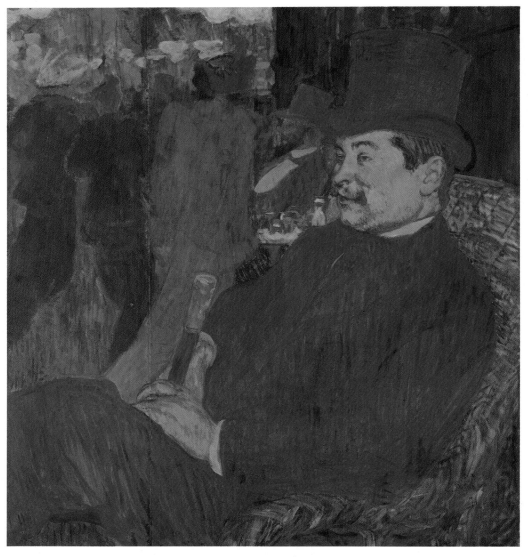

Above: *Monsieur Delaporte at the Jardin de Paris*. 1893. The Jardin de Paris had only just opened when Lautrec painted this portrait of a businessman. It was here that Jane Avril made her name as a dancer. Ny Carlsberg Glyptotek, Copenhagen.

Right: *The Friends*. 1894. Musée Toulouse-Lautrec, Albi.

the top edge of the poster. The orchestral silhouettes, and especially the double-bass necks, are further tributes to Degas, but the general style of the poster is closer to the sinuousness of Art Nouveau than Lautrec's acidulous temperament normally permitted. (Art Nouveau was an international decorative style that made a great impact on the applied arts of the 1890s, including the poster-work of Alphonse Mucha; its most obvious characteristic was a 'whiplash line' often in the form of winding, snake-like flowers and plant tendrils.) Perhaps because she is a member of the audience, Jane Avril is actually smiling in the Divan Japonais poster; elsewhere Lautrec emphasizes her melancholy. In fact this period marked the beginning of her great success. She left the Moulin Rouge, but in 1893 was re-engaged by Oller and Zidler for their new late-night spot, the Jardin de Paris, on the Champs-Elysées, which habitués of the Moulin Rouge could reach at the end of the evening by specially provided omnibuses. Lautrec's poster for Jane Avril's appearance, more audaciously stylized than any he had so far designed, set the seal on his efforts to make her known; as she freely admitted, it was Lautrec who made her a star.

Jane Avril's pallor and reserve set a new fashion that had a particular attraction for the 'decadents' of the '90s, who dreamed of being preyed upon by ghastly vampire-women. One of her most fervent admirers was the English decadent poet Arthur Symons, who emphasized her cruelty and perversity, and her air of 'depraved virginity' – although it seems likely that he was to a considerable extent merely voicing his own fantasies. Lautrec himself had a taste for the morbid and perverse, but he seems not to have found these qualities in Avril. If there was one quality that particularly appealed to him in her – off-stage – it was probably her 'Englishness'. Her professional name was English (or near enough, if you were a Frenchman), her reserve and self-respect were thought of as typically English, and even her costumes resembled those of English showgirls. She even attracted English admirers such as Symons – a trait delightful to Lautrec, who was an Anglomaniac.

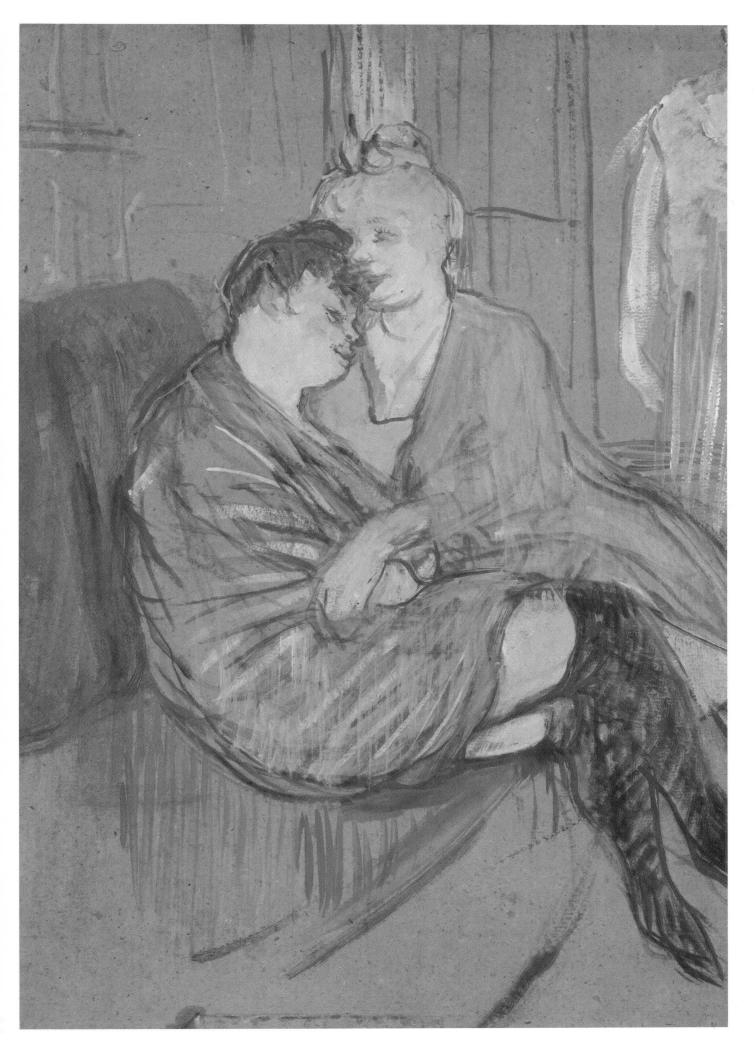

In this, at least, he was not out of the ordinary. French society was going through a phase of wild Anglophilia, stimulated by the social pre-eminence of the Prince of Wales and the adoption by the aristocracy of English institutions such as the Jockey Club and 'le yachting'. The French clubman envied and imitated the Englishman's imperturbability, his avoidance of emotion, and his insistence on 'correctness' (including the observance of tea-drinking rituals) in the most bizarre circumstances – the qualities, in fact, of Phineas Fogg in Jules Verne's *Around the World in Eighty Days* (1873), which fixed the image of the English for generations of Frenchmen. Tailors and English tea-rooms invaded the smart area around the Madeleine, followed, it was claimed, by an army of English beggars. The bars frequented by Lautrec on the Rue Royale had an English tone, particularly (despite the name) his favourite, the Irish and American Bar. And music-hall performers from across the Channel – May Belfort, May Milton, Cissie Loftus – reached a peak of popularity in the mid-'90s and were duly apotheosized by Lautrec. He himself cultivated English friends such as Symons, Charles Conder (who painted exquisitely on silk and fans, and lived grossly in an alcoholic haze), and the *Englishman at the Moulin Rouge* – a man named Warner who was the model for Lautrec's superb lithograph. The painter's conversation was peppered with ejaculations ('Eh! What!') in the English style, though drink brought out an excitability and an exuberant sense of fun that contemporaries would have thought most un-English. On a deeper level, English stoicism appealed to Lautrec for obvious personal reasons; his own sense of 'good form' did not permit him to refer to his physical disabilities except in jest, and it suited him to avoid burdening others with his sorrows and frustrations. Whatever one thinks of the other sides of his life, the way in

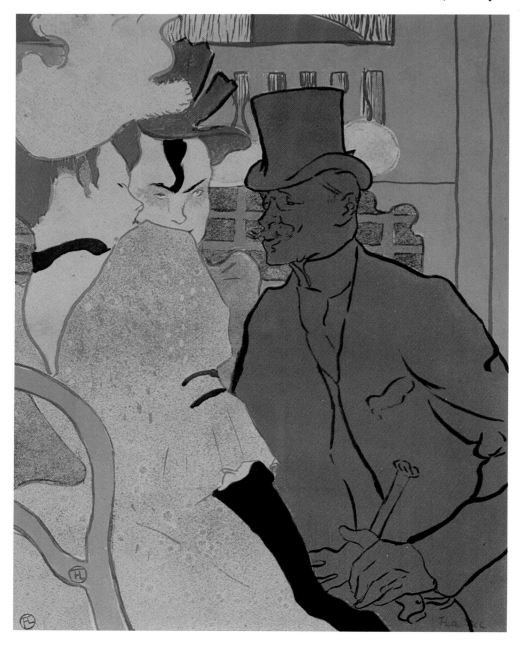

The Englishman at the Moulin Rouge. 1892. The figures in this lithograph represent one of Lautrec's English friends and two Moulin Rouge dancers, Rayon d'Or and Nana La Sauterelle. Musée Toulouse-Lautrec, Albi.

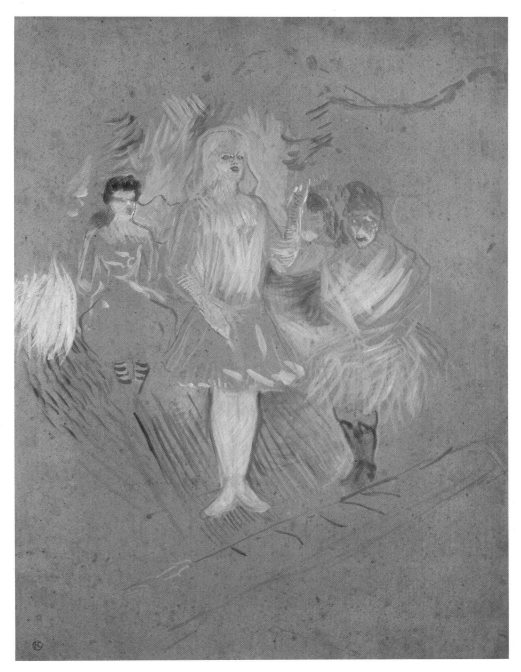

*At the Folies-
Bergères.* 1894.
Musée Toulouse-
Lautrec, Albi.

which Lautrec bore its central tragedy gives him a heroic dignity that nothing can
diminish.

In the course of time Lautrec got out of Montmartre more often. He was attrac-
ted by the bars in the Rue Royale, and also by the brothels, which were centrally
placed for the convenience of genteel customers; Lautrec's favourites were all
within a hundred yards or so of the Paris Opéra, a cultural fact that may or may not
be worth pondering. Lautrec was also drawn in the wake of successful performers
who left Montmartre to find a wider audience. Aristide Bruant had appeared at the
Ambassadeurs in the Champs-Elysées, almost next door to the Jardin de Paris
where Jane Avril was to make her name. (Bruant had asked Lautrec to design the
poster announcing this event; the result, one of Lautrec's masterpieces, was used
by a reluctant manager only when Bruant threatened to walk out.) And further
east, beyond the Opéra, the Folies-Bergères was establishing itself as a rival to the
attractions of Montmartre, putting on variety shows, boxing matches and other
spectacles on a grand scale. The Folies sensation of 1893 was an American dancer,
Loie Fuller, who manipulated large, swirling draperies under changing coloured
lights; in photographs – and in Lautrec's versions of her dancing – her drapes flare
out like great wings, making her look like some exotic bird or butterfly. He painted
her once in a sketchy but expressive style, and he designed a colour lithograph
which, though sprinkled with gold dust, is oddly blob-like and unexciting. As but-
terfly, flower, serpent or flame, Loie Fuller embodied the peculiar, restless beauty
of Art Nouveau, all arabesques and natural ornament; and that may be why she did

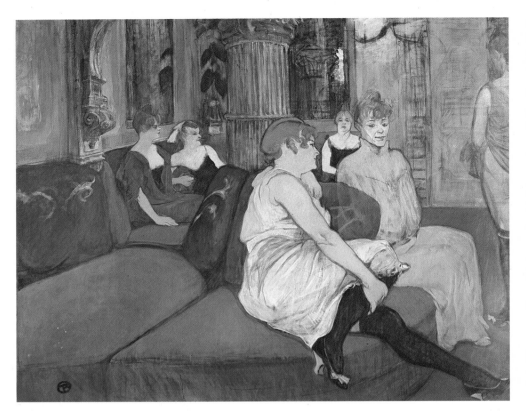

Right: *The Salon at the Rue des Moulins*. 1894. One of Lautrec's most ambitious paintings, showing the madame and the girls of a luxurious Parisian brothel. Musée Toulouse-Lautrec, Albi.

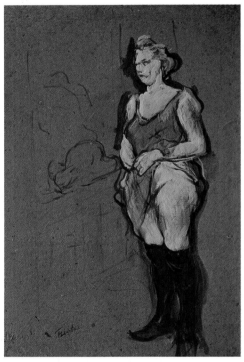

Above: *Woman in Front of a Bed*. 1895. Musée du Louvre, Paris.

Far right: *Woman Pulling on her Stockings*. 1894. Musée Toulouse-Lautrec, Albi.

not inspire Lautrec or hold his attention for long. (Though another reason may have been that she did not come to him for a poster advertising her act.) Lautrec's genius was perhaps too ruthless for such a subject, unless compelled to glamorize it in the service of the commercial poster.

His vision of the high-class brothels of Paris is anything but glamorous. He visited and sketched in these *maisons closes* for some years, and from about 1894 to 1896 he actually lived and worked in them for long periods. For Lautrec their attraction was both personal and artistic. He felt less abnormal in these places where all tastes were catered for, and no deformity or perversion shocked the inhabitants; and he enjoyed a comfortable camaraderie among women with whom he could chatter, drink, play cards, or have sex, without tension or commitment. As they grew used to his presence, they went about their business as if he was not there; they were in any case used to walking about half-dressed, and so moved more naturally than professional models. A painting such as *Woman Pulling on her Stockings* (1894) shows how Lautrec was able to exploit the situation in a study executed as rapidly and spontaneously as a drawing. Brothels inspired scores of his works, from sketches to long-meditated paintings such as the large and ambitious *Salon at the Rue des Moulins* of 1894, for which Lautrec made countless preparatory studies. It shows the madame and girls of an establishment, newly opened in that year, which became Lautrec's favourite *bordel*. This was no squalid 'house of ill fame', but a luxuriously appointed place, just off the Rue de l'Opéra, that serviced a moneyed clientele. The salon, where customers were received, was decorated in 'Moorish' style; the bedrooms were 'medieval', 'Chinese' and so on. The heavy vulgarity of it all reflects the shortcomings of contemporary taste rather than the moral turpitude of the proprietors. In these surroundings, men could act out their fantasies, and in the corridors the girls came and went in all sorts of costumes. Lautrec enjoyed recounting what he had seen, yet this side of life in a brothel is hardly reflected at all in his work. He stresses neither the glamorous nor the bizarre; it is the women, not their relationship with the customers, that interests him. In fact his most overt reference to their profession occurs in the *Medical Inspection* (1894; National Gallery of Art, Washington), in which two of the inmates queue up in a matter-of-fact way, their shifts held above their thighs, for the compulsory monthly inspection to make sure they were free from infection.

Here and elsewhere, Lautrec sees the women coldly, without sentimentalizing them or moralizing over them; if we do not feel that the good life is being led in the Rue des Moulins, it is not because of the trade there, but because the good life itself hardly enters into Lautrec's scheme of things. The most affectionate of his brothel paintings are scenes of the lesbian attachments that quite often sprang up in a world where men figured only as paying guests, and where another woman was

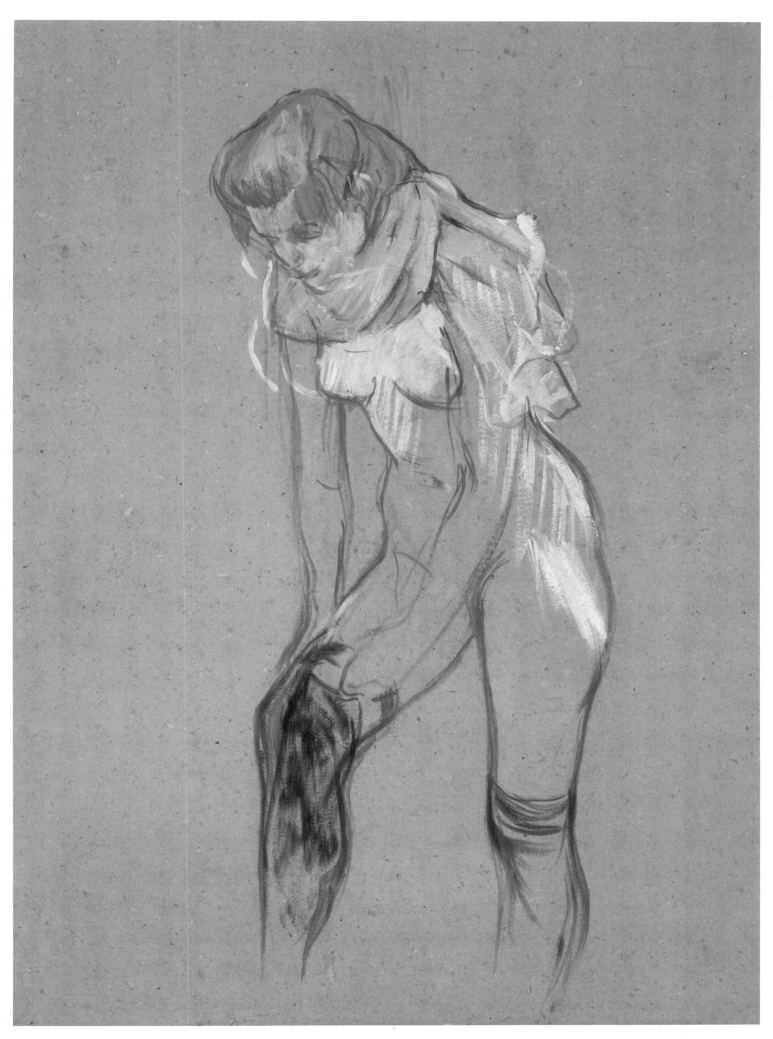

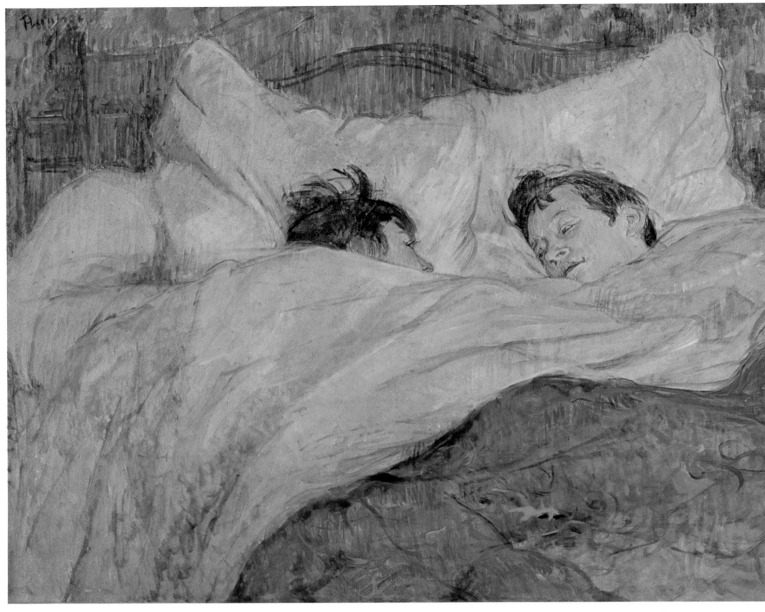

more likely to offer friendship, comfort and considerate love-making. *The Bed* (1893) is as close as Lautrec ever came to celebrating the domestic joys – 'the deep, deep peace of the double bed'. The *Two Waltzers* (1892) and the *Two Friends* (1894) are also quite touching. But Lautrec's interest in the subject was intensely erotic and voyeuristic too, lasting for years and leading him to stage (and presumably pay for) premeditated orgies. As so often his art is more restrained than his life, although paintings such as *The Kiss* (1892), *Two Friends* (1895) and *Abandon* (or *The Friends*, 1895; private collection, Zürich) were sufficiently shocking to his contemporaries. Oddly enough, lesbianism was also remarkably prevalent in the world of entertainment that held such fascination for Lautrec; La Goulue and La Môme Fromage, Jane Avril, May Belfort and May Milton, the female clown Cha-U-Kao – all had partial or exclusive relations with other women, though to what extent that fact was responsible for Lautrec's interest in them is another matter.

The most durable French star of the '90s was Yvette Guilbert, another performer who had begun at the Moulin Rouge but made her name in the more intimate and intelligent atmosphere of the cabaret and café-concert. She had developed an audacious personal style by emphasizing physical features that others would have concealed – her small face with its round eyes, long nose and wide mouth, her long neck and the long thin arms which she drew attention to by wearing long black gloves when every other woman wore white ones. In combination, these features gave her an utterly distinctive look of jaunty attenuation and angularity. At this time she sang risqué material which gained in impact (and appeared to audiences better than it was) because of the way she put it over, half-speaking and half-singing it with impeccable articulation while remaining quite immobile; gestures would have pointed up the sentimentality or vulgarity of words that from

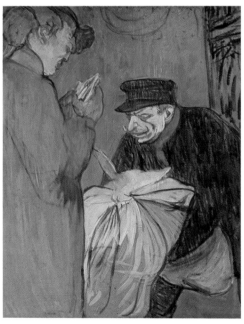

The Laundryman Calling at the Brothel. 1894. One of Lautrec's more sardonic, cartoon-like comments on life in a brothel. Musée Toulouse-Lautrec, Albi.

Guilbert's mouth could seem starkly tragic or wittily aphoristic. She also delivered monologues and – such was the Anglomania of the '90s – sang in English (of a sort) the popular

Linger longer, Lucy
Linger longer, Loo
Linger longer, longer linger
Linger long at you.

Listen what I say
I tell you I am true
I longer linger, longer linger
Linger long at you.

In the early '90s, when Yvette Guilbert was making her name, Lautrec took little notice of her existence. He may well have been too obsessed with Jane Avril and her career to admire a rival; in his poster *Le Divan Japonais*, the chief figure is Avril as one of the audience, while the star, Guilbert, appears in the background on stage, headless, but recognizable by her long neck and black gloves. Later, he drew her a couple of times for magazine illustrations; but by 1894, when Lautrec became interested in designing a poster for her, she had scaled the heights, captivating Paris and London, and had to be wooed. Lautrec sent her a sketch, but she put him off by saying that the poster for her season had already been commissioned – and asking him to make her look less ugly in future – 'just a little less!' Undeterred, Lautrec went on to produce a set of sixteen lithographs for an *Yvette Guilbert* album with a text by one of his friends, the critic Gustave Geffroy. The singer signed the limited edition of a hundred copies with some misgivings, but the work was so favourably received that she was delighted. It was one of Lautrec's most inspired productions. The front cover showed the famous gloves laid out like some two-handed creature with a life of its own, and it was followed by studies of Guilbert in a variety of stage moods that evidently captured the essential quality of her personality, ending with *Yvette Guilbert Taking a Curtain Call*. Her reservations about Lautrec's work, though often criticized with hindsight, are perfectly understandable. Photographs show that, off-stage, she was a rather attractive if unusual-looking woman; Lautrec worked from her stage appearance, already exaggerated by artifice and the relatively crude lighting of the period, and then exaggerated the exaggeration in a way that even a publicity-conscious woman found hard to accept. Some of Lautrec's pen sketches of her, made when they had become better acquainted, are even more outrageously caricatured. All the same, they did become friends, and he even produced a rather glamorous coloured drawing for the magazine *Le Rire*, showing her singing 'Linger Longer, Loo'; according to newspaper

Left: *The Bed*. 1893. One of Lautrec's most touching records of lesbian attachment. Musée du Louvre, Paris.

Below: *Abandon*. 1895. Private collection, Zurich.

59

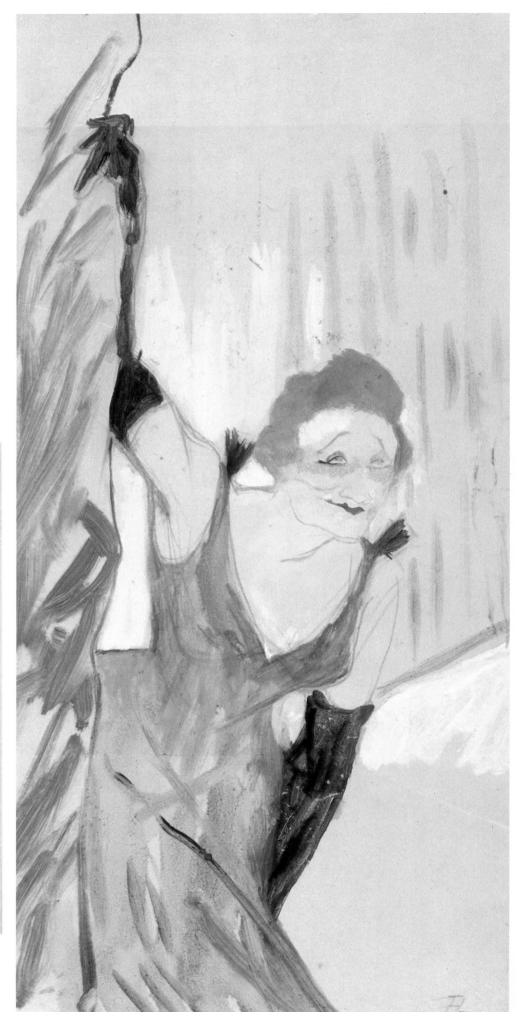

Right: *Yvette Guilbert Taking a Curtain Call*.
1894. This is a curious composite work:
Lautrec painted it on to an enlarged
photograph of his own lithograph on the
subject! Musée Toulouse-Lautrec, Albi.

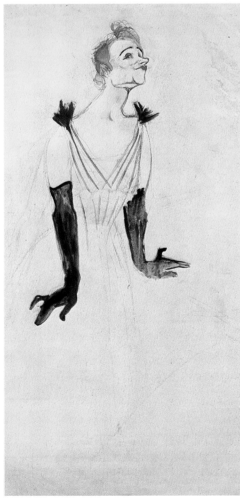

Above: *Yvette Guilbert*. 1894. Study for a
poster, in charcoal and colours thinned with
spirit. Musée Toulouse-Lautrec, Albi.

accounts – which are naturally suspect when it comes to showbiz anecdotes – Guilbert sat for the drawing out of friendship, when she was about to leave for London, and treated him to a private performance of the song. After 1894 they saw relatively little of each other, although as late as 1898 Lautrec published a set of lithographs in which Yvette Guilbert is shown performing her most famous songs.

Lautrec was at his most prolific in the years 1893–94, executing almost 100 paintings, 120-odd prints (lithographs, posters, etc.) and countless sketches. He designed not only posters but book covers and song sheets (including, inevitably, such Yvette Guilbert favourites as 'Eros Vanné'). And he continued to discover fresh interests. New music-hall performers such as Ida Heath and Cissie Loftus briefly engaged his attention, and for the first time he began to attend the 'legitimate' theatre regularly. Although he had even earlier (1893) designed a lithograph of Sarah Bernhardt in *Phèdre*, his interest in this kind of theatre had been sporadic until he made a new friend in the novelist Romain Coolus, who had a passion for the drama. Lautrec went to the theatre with Coolus; in return, Coolus had to set up his writing desk in Lautrec's favoured brothels. As a result of this arrangement, in 1894–95 Lautrec was often present at the Comédie-Française and Théâtre Français, making studies of Réjane, Marguerite Moréno, Marthe Brandès and other leading players. He also got to know the flamboyant actor-manager Lugné-Poë, who championed Ibsen and other 'advanced' dramatists at his Théâtre de l'Oeuvre; Lautrec designed programmes for Lugné and even painted the scenery for one of his productions. However, he was most enthusiastic about Marcelle Lender, an actress at the Théâtre des Variétés who appeared in the operetta *Chilpéric*, dancing the bolero and fandago; when the long-suffering Coolus objected to sitting through a dozen performances of this undistinguished piece, Lautrec replied that he came only to see Lender's back, which was 'the most beautiful in Paris'! In fact – as Coolus knew very well – he was sketching her assiduously, and

Portrait of Romain Coolus. 1899. Coolus was already a friend of several years' standing when this was painted. Musée Toulouse-Lautrec, Albi.

The Box with a Gilded Mask. 1893–94. This lithograph is a theatre programme for a play *The Missionary*, staged at the Théâtre Libre in Paris. Bibliothèque de l'Arsenal, Paris.

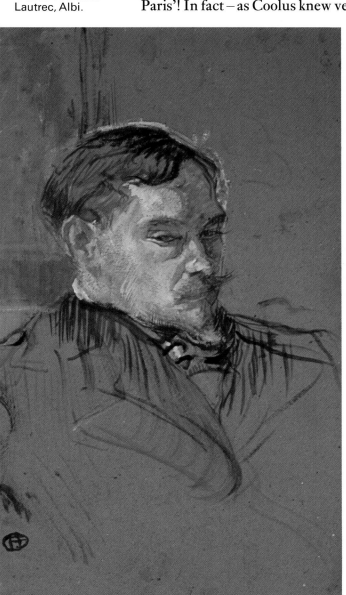

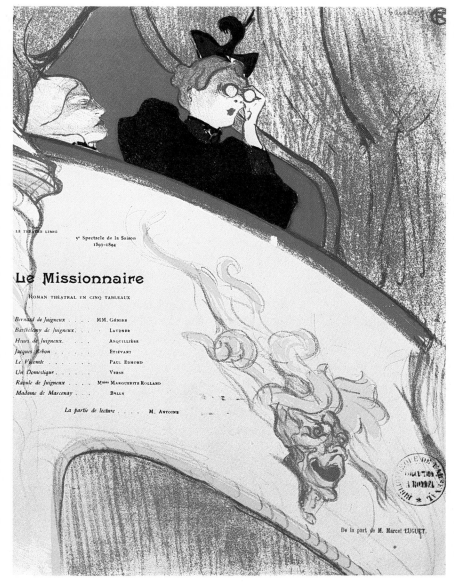

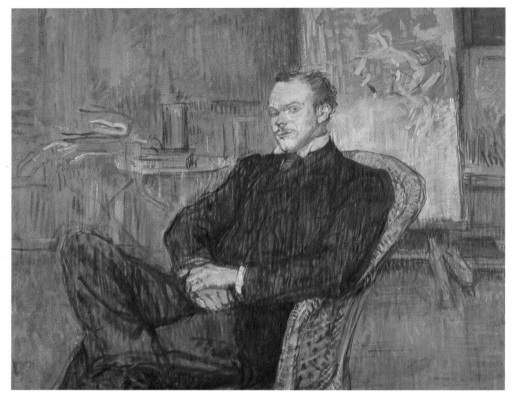

eventually turned his sketches into a set of lithographs and a large painting, *Marcelle Lender Dancing in 'Chilpéric'* (1895; private collection, New York).

Lautrec had met Coolus and Lugné-Poë through the brothers Alexandre and Thadée Natanson, who had an extraordinary appreciation of all that was best in 'modern' art, which they promoted through their magazine, the *Revue Blanche*. By way of the Natansons, Lautrec became acquainted with a much more cultivated circle than he was accustomed to, although he seems to have adjusted to it without difficulty. Thadée's wife, Misia, was a beautiful young woman with an exquisite personal style and a gift for inspiring devotion in artists. Among the *Revue Blanche* writers, Lautrec became friendly with Coolus, with Paul Leclerq (the original founder of the *Revue*), and with the lawyer-turned-journalist Tristan Bernard, who edited the magazine. Lautrec painted all three in subsequent years, and also the artist Cipa Godebski, Misia's half-brother. As always, his social contacts gave rise to more work. Coolus made him more aware of the theatre; Tristan Bernard introduced him to the exciting world of cycle-racing, which was just becoming a national craze. Lautrec produced a number of drawings, paintings and posters concerned with cycling (*La Chaîne Simpson*, *Tristan Bernard at the Buffalo Stadium*), and this interest seems to have led him on to other sporting topics, most notably horse racing (*The Jockey*). For the *Revue Blanche* itself he produced a delightful poster featuring Misia (1895). The magazine's artistic contributors included Pierre Bonnard and Édouard Vuillard. Vuillard was on particularly good terms with Lautrec, painting two studies of him including a candid but wholly sympathetic portrait of him (1898) at Thadée Natanson's country house at Villeneuve-sur-Yonne.

In February 1895, when Vuillard completed a set of ten decorative paintings for Alexandre Natanson, Lautrec took charge of the ensuing celebrations at Natanson's house in the Avenue du Bois-de-Boulogne. He designed the invitation cards, set up a long 'American Bar', and himself mixed and served a variety of lethal cocktails that put most of the Parisian avant-garde out of action for the next few days; the occasion became a legend in the cultural history of the period.

In the spring of 1895 Lautrec accompanied Joyant on a trip to England. Despite his admiration for all things English, the painter preferred the glamorized Englishness of the Rue Royale bars to the sober reality, and his visits were always quite brief. The reality was not, in truth, sober; but the English did their drinking with such gloom and guilt that Lautrec lost much of his enthusiasm for alcohol, and even tended to drink less than usual. His most interesting encounter was with the dramatist Oscar Wilde, who was about to stand trial for his homosexual practices. Wilde had not long before been enormously popular; now he was already being ostracized by many people, and was soon to know imprisonment, financial ruin,

exile and death. Lautrec and other members of the *Revue Blanche* circle were indignant at Wilde's martyrdom, but Lautrec's portrait of him, done from memory after his return from France, is scarcely kind; the writer's huge, flabby face and small, made-up features create an extremely repulsive impression.

Wilde figures in another work undertaken by Lautrec during that spring. La Goulue had begun to put on weight, her vogue had passed, and she had been quietly dropped from the team of dancers at the Moulin Rouge. But she was still attempting to trade on her former success, appearing as a belly-dancer in her own fairground booth. In April 1895 she wrote to Lautrec, asking him to paint her something to attract customers, and he started two large canvases which he finished in June, after his return from London. They represented the past and the present: in one, La Goulue is shown at the height of her glory, flanked by Valentin le Désossé; in the other, she is performing an 'Egyptian' dance with turbaned assistants and an amusingly frenetic pianist. As so often in Lautrec's work, many of the onlookers and bystanders are real people. In the second panel the audience includes Sescau, Guilbert, Tapié, Jane Avril, Lautrec himself – and also Oscar Wilde (put in, perhaps, as a public gesture of solidarity with the persecuted writer) and the art critic Felix Fénéon, an unmistakable, eccentric figure in his little hat and large-checked coat (though his equally eccentric red gloves are, alas, not

La Goulue and Valentin. 1895. A panel painted for La Goulue's fairground booth, commemorating her days of glory at the Moulin Rouge. Musée du Louvre, Paris.

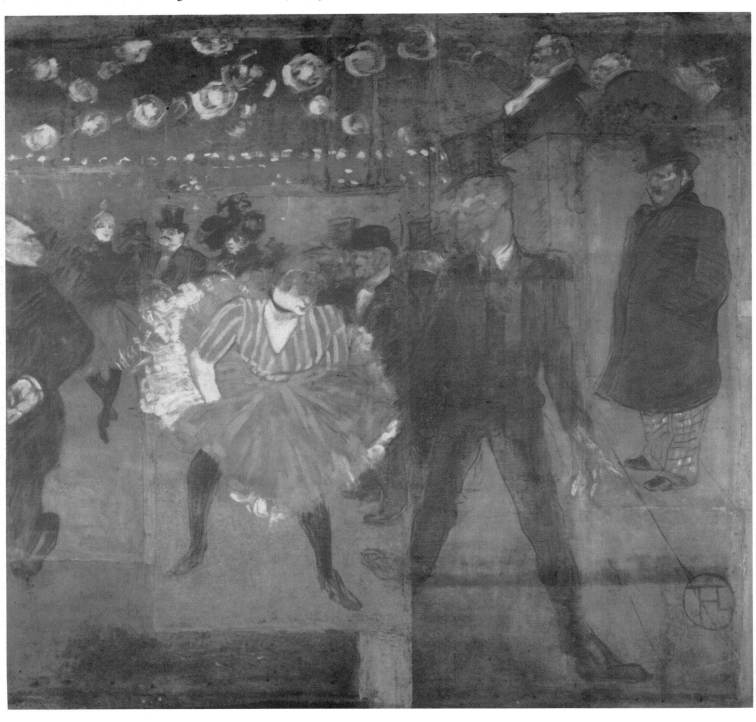

visible). Fénéon was an ex-civil servant who had been dismissed for holding anarchist views, although he had been acquitted after a notorious trial in which Thadée Natanson had been the counsel for his defence; Natanson had afterwards given him a job on the *Revue Blanche*. Fénéon's rather solemn manner delighted Lautrec, who had earlier portrayed the critic on a theatre programme as a Buddha riding on an elephant. The panels for La Goulue's booth enjoyed a great *succès de scandale*, delighting the satirical magazines and outraging conventional artists such as Lautrec's old teacher, Fernand Cormon. Contemporary photographs show how boldly they stood out even when seen at a distance; typically, Lautrec created works of art but also made sure they did the job for which they were requested. They are now in the Louvre, though sadly faded. Time dealt even less kindly with La Goulue herself; after an unsuccessful act as an animal tamer, she sank into alcoholic destitution, lingering on until 1929 – the year the Louvre purchased the panels Lautrec had painted for her booth.

With La Goulue, something of the magic departed from the Moulin Rouge. Valentin retired, and the only dancer of real ability was a versatile performer who called herself Cha-U-Kao; she was also an equestrienne and a clown, appearing at the Moulin Rouge and the Nouveau Cirque (New Circus) in the Rue Saint-Honoré. The origin of her name has a certain interest: she was originally known as

Below: *La Goulue's Egyptian Dance*. 1895. The companion-piece to *La Goulue and Valentin*, painted for the front of La Goulue's fairground booth. It shows the performance she was currently giving. Musée du Louvre, Paris.

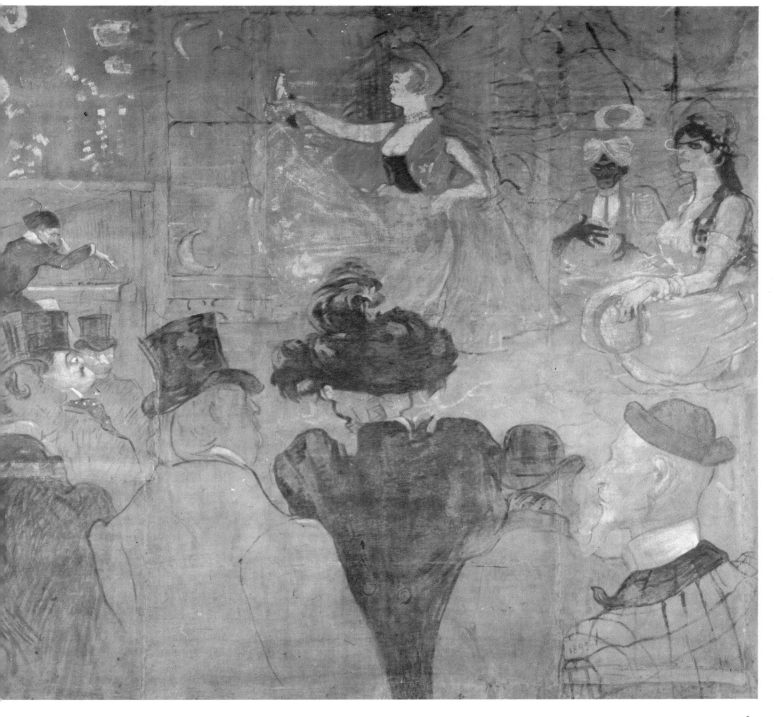

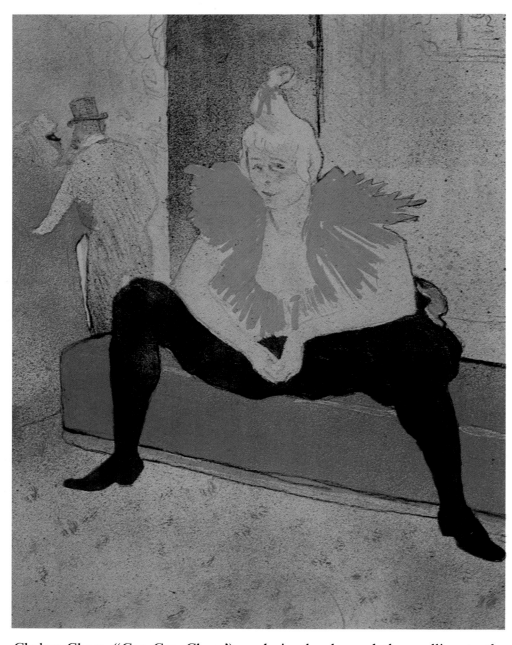

Female Clown Seated. 1896. A lithograph from Lautrec's series *Elles*; the model is the 'clownesse' Cha-U-Kao, one of Lautrec's favourites at this time. Bibliothèque Nationale, Paris.

Right: *The Female Clown Cha-U-Kao.* 1895. Musée du Louvre, Paris.

Chahut-Chaos ('Can-Can Chaos'), and simply changed the spelling to the 'Oriental' Cha-U-Kao, which sounds exactly the same when pronounced in the French manner. Lautrec's main interest was in her as a 'clownesse' (female clowns were rare), clad in a baggy costume with an enormous, low-cut ruff or collar, and wearing a pointed, beribboned headdress. He painted her three times in 1895, later repeating one composition in the form of lithograph; another, justly celebrated, lithograph (*Female Clown Seated*) appeared in the set called *Elles* ('Women'), which was published in 1896. As far as it is possible to judge from photographs, Lautrec rather exaggerated Cha-U-Kao's muscularity in the Louvre painting of her in what seems to be a private supper-room, still dressed in her clown's costume but presumably about to dine tête-à-tête with a gentleman whose image can be seen in a mirror; perhaps Lautrec was drawing a sly contrast between the mighty *clownesse* and her elderly admirer. Elsewhere, Lautrec makes her look almost middle-aged, with more than a hint of a double chin and a somewhat bemused air of benevolence – again an effective contrast, this time with her assertive costume and boisterous surroundings, as in the painting/lithograph of her strolling into the Moulin Rouge on the arm of the dancer Gabrielle.

Lautrec's acquaintance with Cha-U-Kao went back to 1892, when he had portrayed her as one of the *Two Waltzers*. His new interest in her may have been partly occasioned by her lesbianism, a subject that now obsessed him more than ever. He spent a good deal of time over the next few years at La Souris and other lesbian bars, where he established himself as a privileged being, part-jester and part-confidant to the regular customers. As we have seen, his interest sometimes also took a more openly voyeuristic form.

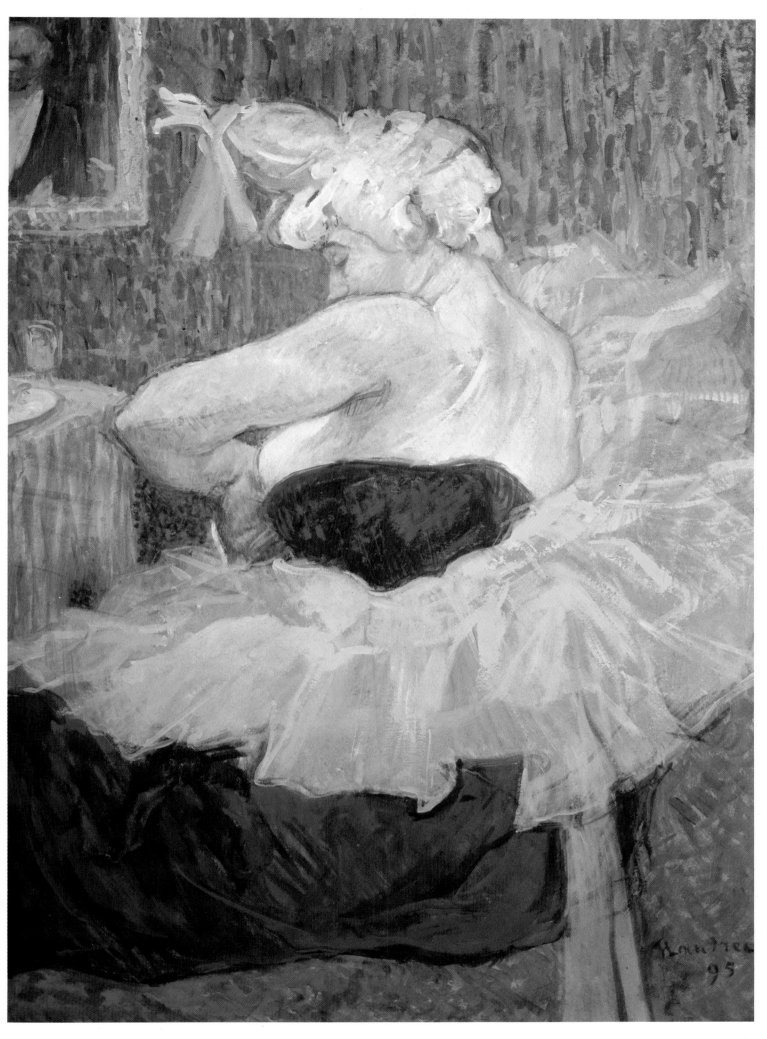

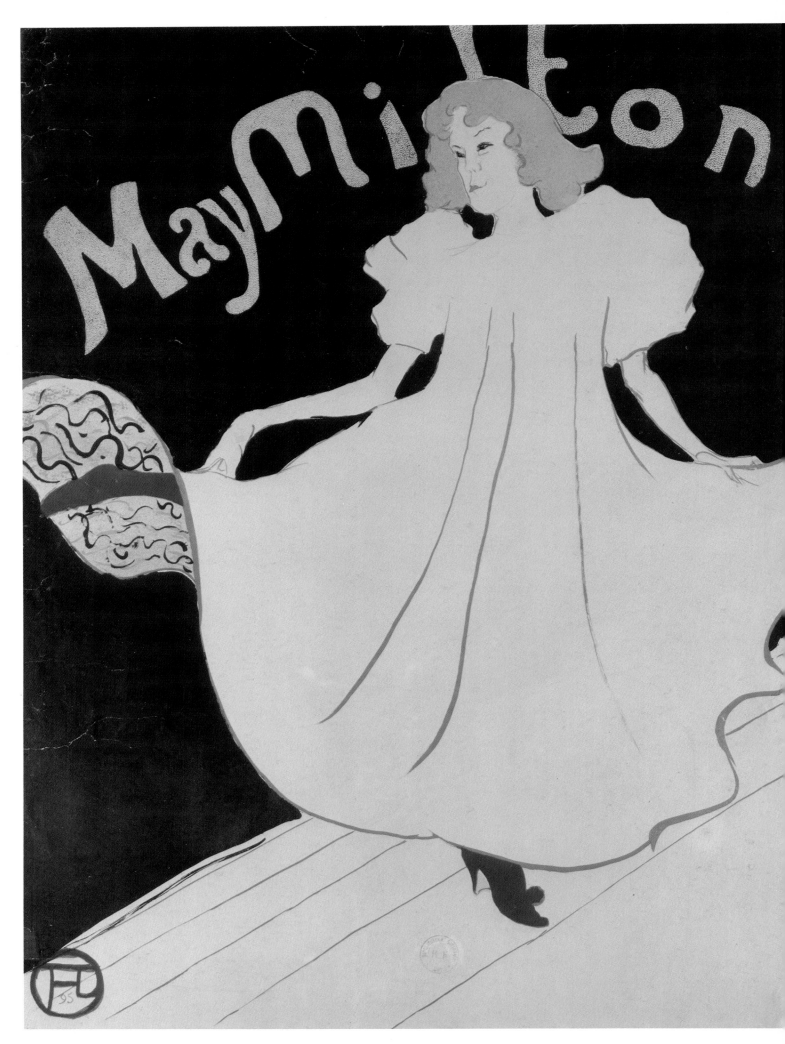

Lautrec's enthusiasm for the Sapphic and the Anglomaniac were on occasion combined. In 1895 he designed a poster for the English dancer May Milton, whose vogue was so brief that very little is known about her; she seems to have had affairs with both Jane Avril and the Irish singer May Belfort. Lautrec's red poster for the latter was intended to make a pair with the blue of May Milton's. The Belfort poster was the more striking, accurately evoking the atmosphere of her act, even down to the 'childish' lettering. Dressed like a child and carrying a kitten in her arms, May Belfort lisped out:

> *I've got a little cat*
> *And I'm very fond of that*
> *But I'd rather have a bow-wow-wow . . .*

Since she appeared at the notorious Théâtre des Decadents, her little-girl appeal was evidently regarded as sexually titillating. In life she seems to have had some very odd tastes indeed – but as one of them was for the Irish and American Bar, she and Lautrec got on together very well. In the poster her performance is made to look innocuous enough, but in other lithographs, and in a number of paintings of her, her equivocal, almost sinister appeal is unblinkingly recorded.

Yet another of Lautrec's enthusiasms of the later '90s was for the clowns Footit and Chocolat, who appeared both separately and together at the Nouveau Cirque and elsewhere. Chocolat, a black man, was also a talented dancer, caught with particular effect by Lautrec in *Chocolat Dancing in the Bar d'Achille* (1896). Footit was

Below: *Chocolat Dancing in Achille's Bar.* 1896. Gouache drawing of a black circus clown whom Lautrec admired. Here he is dancing at the Irish and American Bar, one of Lautrec's favourite haunts: the Swiss proprietor, Achille, standing at the left, looks on. Musée Toulouse-Lautrec, Albi.

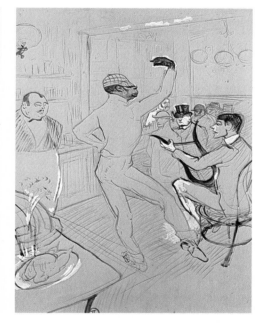

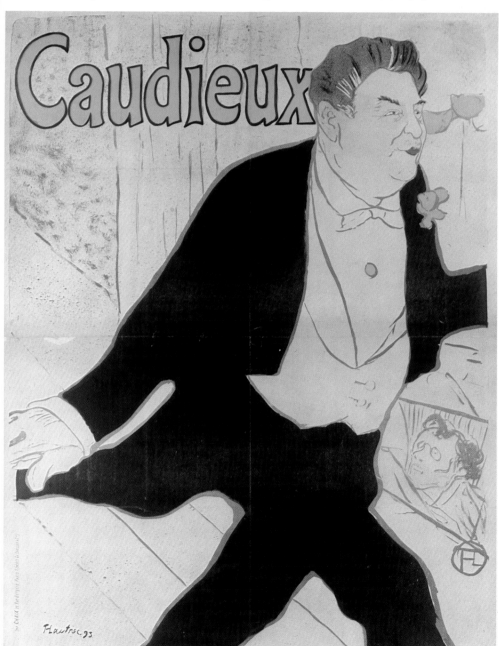

Left: *Caudieux.* 1893. Poster for a popular comedian-singer. Private collection.

Far left: *May Milton.* 1895. Poster for an English dancer who enjoyed a brief popularity in Paris. Bibliothèque Nationale, Paris.

an Englishman who had been an equestrian until he had lost his horse in a poker game, after which he had – under compulsion – discovered a talent for clowning. He belonged to the breed of sad clowns whose melancholy provokes laughter and, if Lautrec's sketches and lithographs can be relied on, his gloomy appearance seems to have been maintained in his everyday life and not merely assumed when he was performing.

In spite of so many distractions, Lautrec spent part of each summer at Malromé, the country house his mother had bought in the south-west. To get there he would take a train to Le Havre, and then travel as far as Bordeaux by a cargo boat bound for Dakar in West Africa. But in 1895 the pattern was broken for once. He became spellbound by a beautiful girl who occupied cabin No. 54, though he had never so much as spoken to her. Overruling the objections of his travelling companion, **Maurice Guibert**, Lautrec refused to leave the boat at Bordeaux, though he subsequently made no attempt to approach the girl; presumably he was simply hoping for a miracle of some sort to occur. At Lisbon, Guibert succeeded in persuading a reluctant Lautrec to go ashore; the girl went on to join her husband at Dakar, while Lautrec and Guibert sampled the brothels of Lisbon and Madrid, and the paintings by El Greco in the Prado collection. The episode reveals Lautrec's suppressed romanticism, and perhaps also his increasing capriciousness. Like so much else in his existence, it found its fulfilment only in art: the *Passenger in No. 54*, a superb lithograph of the unknown girl, a little boater perched on her mass of red hair, seated on deck under a parasol.

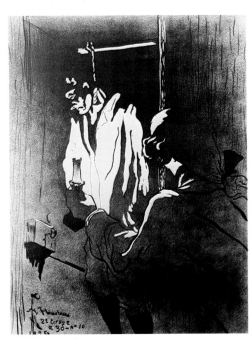

Below: *The Hanged Man*. 1895. A version ('second state') of a poster originally printed in 1892. Staatliches Museen, Dresden.

Right: *Napoleon*. 1895. Lautrec submitted this design in a competition; the winner's work was to be used as a poster to advertise a new biography of the French emperor. Lautrec's entry was unsuccessful. Musée Toulouse-Lautrec, Albi.

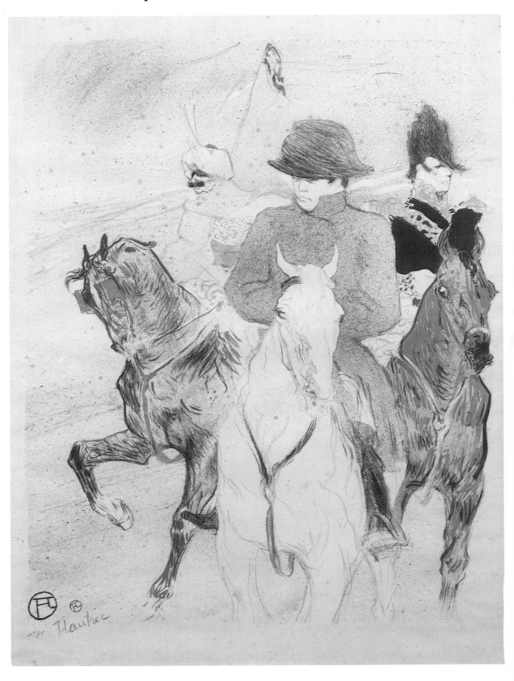

Self-Destruction

By the end of 1895 Lautrec had become involved with an amazing number of people, places and activities, almost all of which became subjects for his art. In some (for example, May Milton and May Belfort), his interest was intense but brief; but many others supplied him with material until the end of his life. Bearing this in mind, we can now give most of our attention to the facts of Lautrec's later life, which became increasingly sad and sordid.

The year 1896 began promisingly. Joyant had opened a gallery in partnership with a fellow-employee, Michel Manzi, and in January Lautrec had his first solo exhibition at the Galerie Manzi-Joyant in the Rue Forest. As usual, critical reaction was mixed, although Lautrec made an attempt to conciliate bourgeois opinion by showing his more shocking works in a separate room to which only his allies were admitted. From about this time his paintings began to command respectable prices, entering the collections of connoisseurs such as the banker Isaac de Camondo, who eventually left one of the most important legacies of Impressionist and Post-Impressionist art to the Louvre. The ability to earn money became more important to Lautrec as his family became more and more reluctant to finance his self-destructive way of life, which had at last begun to take a visible toll. In 1896 his work was as good as ever, even if he was becoming less prolific; but in 1897–98 his output fell steeply and became more uneven in quality. Where he had once been able to absorb incredible quantities of drink without the slightest change of demeanour, he now frequently became so hopelessly drunk that he had to be brought

La Revue Blanche. 1895. Poster for the magazine run by Lautrec's friends the Natansons. The female figure is a portrait of Thadée Natanson's wife, Misia. Musée Toulouse-Lautrec, Albi.

La Vâche Enragée. 1896. Poster for a monthly illustrated magazine; the title means 'The Infuriated Cow'. Musée Toulouse-Lautrec, Albi.

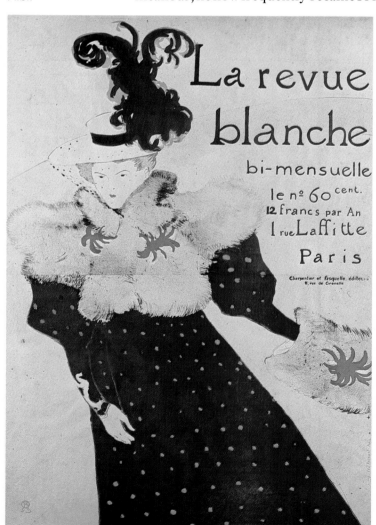

home unconscious. His self-control relaxed, and he began to fall into alcoholic rages, to tyrannize without any of his old charm or sense of limits, to haunt squalid places, and to get into trouble with the police. In one of his scrapes he fell down a flight of steps and broke his collar-bone; in another, he gratuitously insulted the ex-king of Serbia – an admirer and purchaser of his work – by vulgar comparisons between the antiquity of his own family and the Obrenovic dynasty. His face bloated and pasty from his excesses, he was now physically repulsive to even the friendliest eye.

In these circumstances, it says a good deal for Lautrec's friends that they rallied to him instead of leaving him to his own devices. Individual and concerted efforts were made to get him away from the capital as often as possible. He was persuaded to take a long holiday at Taussat, a resort in the south-west where he could fish and sail; Joyant carried him off to Le Crotoy on the Channel coast; the Natansons invited him to their new country house at Villeneuve-sur-Yonne; and with Dethomas he went on a trip to Holland, where he admired Hals' paintings at Haarlem but was upset by the way in which the country people treated him as a freak. Impressed by the avant-garde artists he met in Holland – and especially by Henry van de Velde, who even served food that harmonized with the décor of his house – Lautrec enthusiastically decorated his new studio in Art Nouveau style, and invited his friends to a 'milk-drinking' house-warming – with cocktails for the gentlemen. But he was soon drawn back to more disreputable places and more compulsive drinking. Then Joyant devised an even more desperate expedient: he arranged for an exhibition of Lautrec's work in London, at Goupil's (a branch of Boussod et Valadon) in Regent Street. According to plan, Lautrec was harmlessly occupied in selecting and supervising, and as always he drank less in London; but since the English were even more conservative than the French in their artistic tastes, the exhibition was a resounding failure. One nice display of Franco-British *sang-froid*

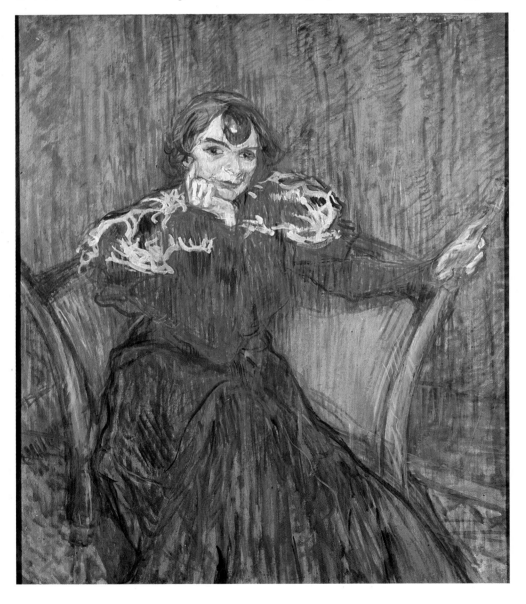

Portrait of Berthe Bady. 1897. Bady was an actress of some distinction. Musée Toulouse-Lautrec, Albi.

Right: *The Country Outing*. 1897. The subject and treatment of this charming lithograph are very unusual for Lautrec. Cabinet des Estampes, Bibliothèque Nationale, Paris.

Above: *Viaud as an Admiral*. 1900–01. An odd painting, done at the home of Lautrec's mother at Malromé. The 'admiral' is Lautrec's relative and 'keeper', Paul Viaud, who was employed to try and control Lautrec's drinking. Museo de Arte, Sao Paolo.

is said to have occurred at Goupil's. The Prince of Wales had been invited to the private view held before the exhibition was thrown open to the public. When he failed to turn up on time, Lautrec displayed his aristocratic calm by falling asleep. On his arrival, the Prince insisted that the painter should not be woken up. 'Good fellow, that!' said Lautrec.

Lautrec was not unduly upset by his failure in London. Indeed, one of the alarming symptoms of his condition was a growing indifference to his work, or perhaps it would be more accurate to say that he had lost his faith in its importance and its power to bring him happiness. On moving from his studio, he is said to have left no less than eighty-seven paintings behind, telling the concierge to do what he pleased with them (as a result of which, only one survived). He worked less, and left more works unfinished. Much of what he did was still of high quality: in 1897, portraits of Berthe Bady, Leclerq and Misia, and the charming and uncharacteristically sweet lithograph *Country Outing*; in 1898, another Yvette Guilbert album and the illustrations for Jules Renard's *Histoires Naturelles*, for which he paid many visits to the zoo in the Jardin des Plantes. But by 1898 his output was ominously small, and despite all his friends' efforts he was obviously heading for a complete breakdown. He suffered from hallucinations and paranoid fears; his drawings became tremulous and grotesque; and in February 1899 he suffered a violent attack of delirium tremens.

When Lautrec returned to ordinary consciousness, he found himself under lock and key in a sanatorium to which his mother and his friends had committed him after a good deal of heart-searching. In many respects he was lucky: the Château Saint-James in Neuilly was a pleasant private establishment for well-off patients, and Lautrec received more freedom and consideration there than a poor man's son would have been offered in a public ward. But confinement and supervision were intolerable to a man who had always done exactly as he pleased, and they appear to have stimulated Lautrec into making a remarkable recovery. He was, in addition, terrified of being labelled 'mad' and permanently incarcerated. To prove his sanity and fitness, he began to work again. Of the fifty-odd items he produced, the most interesting are thirty-seven in which he returned to his old passion for the circus; many of them are coloured pencil drawings, pretty and charming if rather innocuous – which was perhaps what he believed would most effectively impress his captors. The moment of his 'escape' was brought closer by a visit from the critic of the newspaper *Le Figaro*, who afterwards published an article describing Lautrec's return to health and creativity. The piece had been written to refute attacks on Lautrec, who was being pictured as a degenerate artist who had at last found his proper place in a madhouse; but it also helped to convince Countess Adèle that her son was fit enough to return to the world. In May he was released from the sanatorium but was provided with a companion-keeper in the person of Paul Viaud, a

distant relative of amiable disposition who had fallen on hard times. Since Viaud did his job with tact, the two men got on well together, and for a time it seemed that Lautrec had really made up his mind to live and thrive.

Most of the next few months were spent out of Paris, at Le Crotoy, Le Havre and Taussat. Lautrec's impulse to work surged up only once, at Le Havre, where he found a congenial atmosphere at Le Star, a place with an English barmaid and a clientele largely composed of English sailors. He wrote to Joyant asking him to send the necessary materials, and stayed on at Le Havre until he had completed a number of sketches (some of them later made into lithographs) and a portrait of 'Miss Dolly', the vivacious barmaid.

Lautrec appears to have resisted temptation at Le Star, but back in Paris during the winter of 1899–1900 he began drinking again; part of the time he was able to do it surreptitiously, taking nips from a special hollow walking stick with a screw top. (Not that Viaud could actually stop Lautrec drinking, though his reports might induce the family to cut his allowance – which they did, reducing Lautrec to fits of impotent rage.) He was nevertheless getting some work done, though it often cost him much more labour than it had in his best years. In the *Private Room at the Rat Mort* (1899) he returned to Montmartre (the Rat Mort – 'Dead Rat' – was a well-known rendezvous on the Place Pigalle). Other works looked further back, to his enthusiasm for horses and horse racing. The lithograph *The Jockey* (1899) is in Lautrec's best Degas-like manner; by contrast, *At the Races*, painted at about the same time, is in the heavier style he had already begun to employ in pictures such as the *Private Room*. Line had always been the single most important element in his works, including his paintings; the deliberate thinness of the paint itself emphasized the fact. Now he was laying on his colours more thickly, and making more use of variations of tone to define shapes. Whether this was done in an attempt to

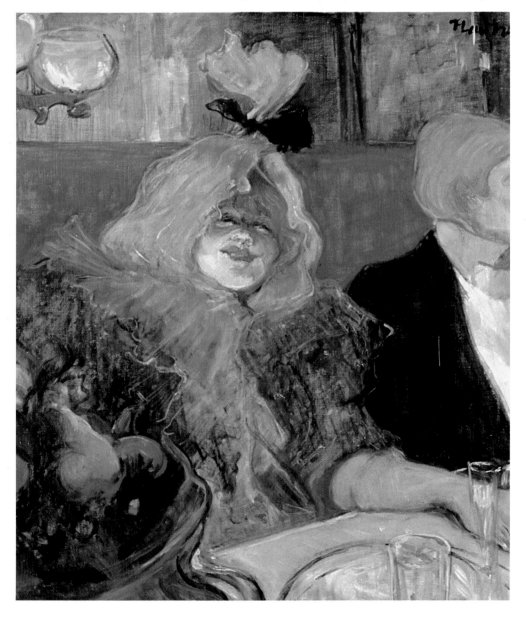

The Private Room at the Rat Mort. 1899. One of Lautrec's most successful works in the richer, more 'painterly' manner he attempted in his last years. Courtauld Institute, London.

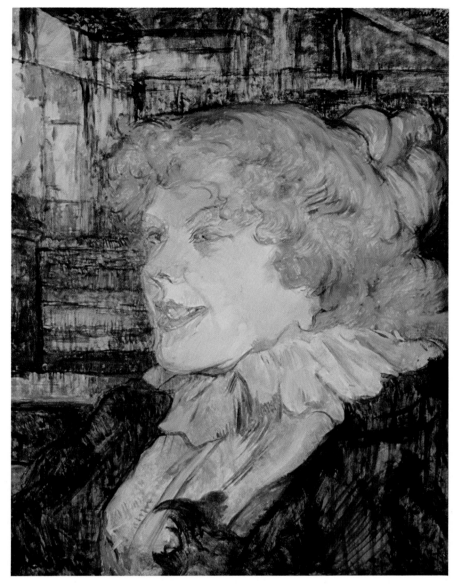

The English Barmaid at Le Star. 1899. After a long unproductive period in the wake of his confinement for alcoholism, Lautrec experienced a fit of artistic enthusiasm for Le Star, a sailors' bar at Le Havre. He stayed on in the town especially to paint this girl, 'Miss Dolly'. Musée Toulouse-Lautrec, Albi.

At the Races. 1899. Musée Toulouse-Lautrec, Albi.

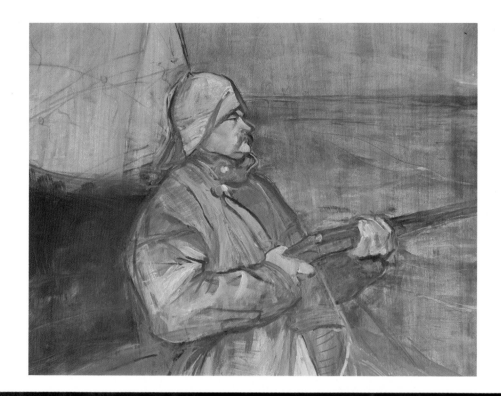

Above: Detail from the *Portrait of Maurice Joyant*. 1900. Joyant was one of the closest of Lautrec's friends, though his efforts to save the painter from self-destruction were unavailing. No longer certain of his touch, Lautrec took over seventy sittings to paint this picture. Musée Toulouse-Lautrec, Albi.

Left: *The Modiste*. 1900. Musée Toulouse-Lautrec, Albi.

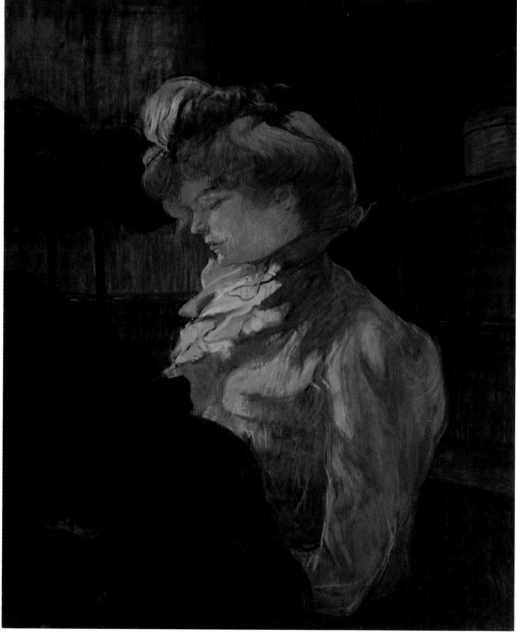

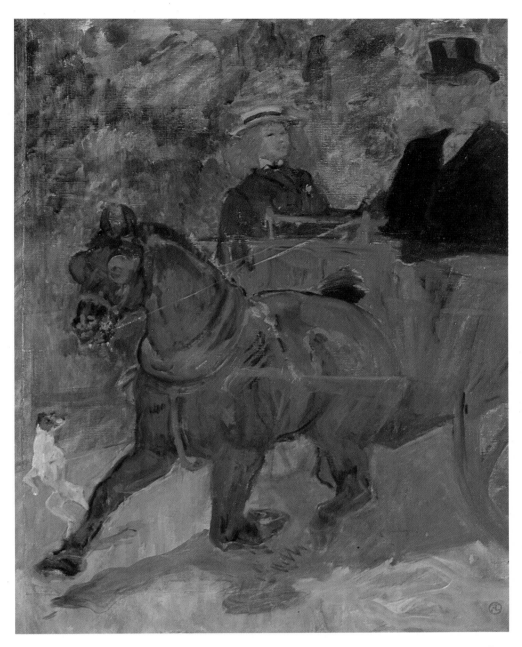

Horse and Trap.
1900. Musée
Toulouse-Lautrec,
Albi.

conceal the failure of his draughtsman's gift, or as a creative new departure, has become a matter of some controversy; what is less in contention is that Lautrec achieved only limited success with the new style before his death. The best of his later works are those closest to his 'linear' style, for example *The Modiste* (1900), a portrait of the milliner Louise Blouet, who for a time became Lautrec's favourite model.

By the summer of 1900 he was working only sporadically and with great difficulty. The situation must have been all the more distressing in that he had always previously been notable for his astounding facility; his portrait of Paul Lerclerq, dating from only three years earlier, had been executed in two or three hours, and as a lithographer he was admired in the profession for his ability to work directly onto the stone from which final prints would be made. Now, painting a portrait of Joyant in oilskins at the Baie de la Somme took over seventy sittings as Lautrec struggled to make his hand obey his will.

Sailing, swimming and fishing again pulled Lautrec round, and enabled him to survive another year. He decided to winter in Bordeaux – a break with his whole pattern of existence that may have reflected a determination to forego the temptations of the capital. If so, the break was a failure: Bordeaux had plenty of brothels and bars of its own. But he did experience a last surge of the will to work. His main inspirations were the students' ball and the Bordeaux Opéra, which put on the operettas *La Belle Hélène* and *Messalina*; he was highly entertained by the leading actresses, Mlle Cocyte and Mlle Ganne, though not always quite in the way they intended. However, *Messalina* gave rise to no less than six paintings in a very broad manner, touched with a certain cruelty.

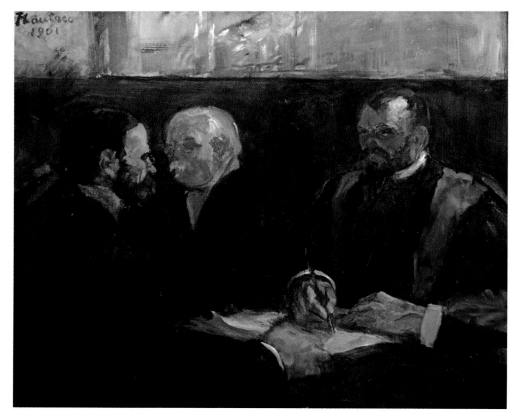

Examination at the Paris Faculty of Medicine. 1901. Lautrec's last completed painting, showing his cousin and friend Tapié defending his doctoral thesis. Musée Toulouse-Lautrec, Albi.

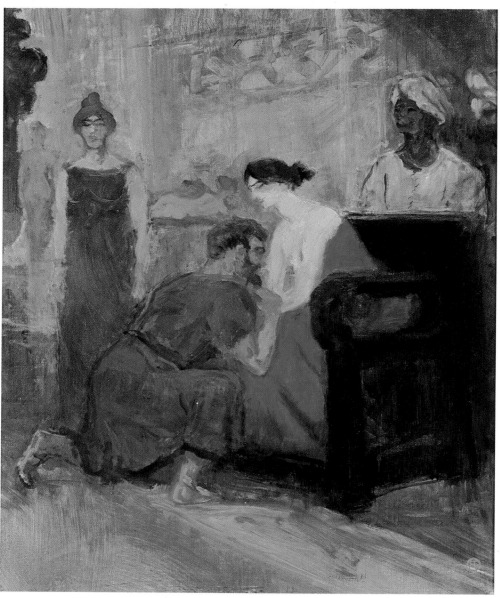

Messalina. 1900. One of six paintings on this subject executed in the winter of 1900–01 at Bordeaux, where Lautrec was chiefly inspired by performances at the Opera. Musée Toulouse-Lautrec, Albi.

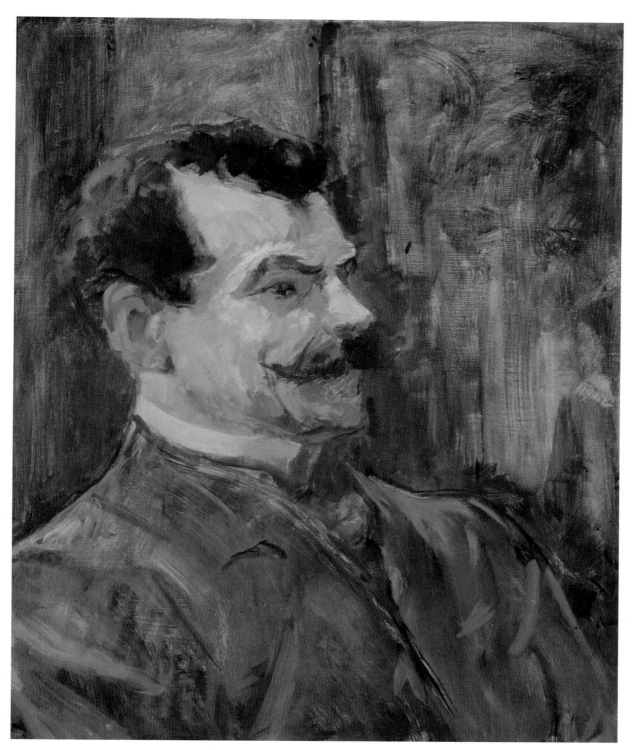

Portrait of André Rivoire. 1901. A painting of a writer friend, done during Lautrec's last summer in Paris, when he seems to have deliberately set out to complete a personal gallery of friends' portraits before his death. Musée du Petit Palais, Paris.

Lautrec was now doomed, and he and most of his friends knew it. He had suffered two paralytic attacks even before returning to Paris in April 1901, and his time in the city appears to have been passed in making his adieux. He visited many of his old haunts in a nostalgic mood; he painted portraits of a few previously unrecorded friends; and he went through the whole stock of pictures in his studio, signing those he judged successful and rejecting the rest. He also painted his cousin Tapié arguing his doctoral thesis at the Faculty of Medicine in Paris – an event that had occurred two years before, and in any case seems an odd choice of subject for Lautrec; it is a competent but conventional and uninspired picture.

In July 1901 Lautrec set off for Taussat. He was no longer the bloated drunkard, but shrunken and grey-faced; and his legs could scarcely support him. This time, the sea air failed to revive him. In mid-August he collapsed completely as a result of a paralytic stroke, and his mother took him back to Malromé to die. This he accomplished according to his own sense of form, remarking quietly that dying was 'damned hard' and saying to Tapié, as he watched his father flicking flies away from the sheets with a piece of elastic, 'Silly old b——.' He died on the morning of 9 September 1901.

Acknowledgments

The photographs in this book were all supplied by Photographie Giraudon, Paris with the exception of the following:

Art Institute of Chicago, Illinois 38 bottom; Hamylyn Group Picture Library front cover, 9 right, 20 left, 23 left, 23 right, 25 right, 27, 28 left, 29, 30 left, 30 right, 32, 37, 38 top, 45 left, 46 bottom, 48, 49 right, 50 right, 52, 54, 56 right, 57, 58 bottom, 60 right, 61 left, 74, 75 top, 75 bottom, 76 top, 76 bottom, 78 top; Musées Nationaux, Paris 13 right, 62; National Gallery, London 12 bottom.

Front cover: *The Englishwoman from the Star at Le Havre.* 1899. Oil on wood. Musée Toulouse-Lautrec, Albi.
Back cover: *Ault and Wiborg Poster.* Musée Toulouse-Lautrec, Albi.
Title page: *The Country Outing.* 1897. Cabinet des Estampes, Bibliothèque Nationale, Paris.
Endpapers: *At the Moulin Rouge: the Dance.* 1890. Henry P. McIlhenny Collection, Philadelphia, Pennsylvania.

Note In 1986 the Musée d'Orsay in Paris was opened. This museum is now assembling under one roof works by French artists dating from the middle of the last century to 1914 from collections in the Louvre, Musée Nationale d'Art Moderne and elsewhere. Some of the works in this book may now be seen there.